# LIVING the ARTIST'S LIFE

"A work of sophistication that resonates with passion, practical guidance and wisdom. It is as engrossing as it is candid."
*Jim Leedy, Professor, Sculpture Department, Kansas City Art Institute*

"An entertaining and highly valuable guide for aspiring and working artists; a much needed addition to the literature of the creative process."
*Murray Dessner, Painting Instructor and Critic, Pennsylvania Academy of the Fine Arts, Philadelphia*

"*Living the Artist's Life* is the most informative, thought-provoking and important book about the development of an artist I have ever read."
*Doug Baldwin, Professor of Ceramics, Maryland Institute, College of Art*

"Mr. Dorrell has lived both the creative life of an artist and the practical life of a gallery owner. This interesting autobiographical work is filled with encouragement and worthwhile advice for the aspiring artist."
*Michele Fricke, Assoc. Professor of Art History, Kansas City Art Institute*

"An intense and personal view of survival in the artbiz. It gives extensive practical and philosophic advice regarding the trials and tribulations of artists and dealers."
*Robert Brawley, Professor of Painting & Drawing, University of Kansas*

"While there are many books out there on creativity and the pitfalls that the artist encounters, few are as personal and comprehensive as this one."
*FiberArts Magazine*

"Dorrell advises on topics from photographing your work to inspiration, depression and self-doubt, as well as getting commissions and getting into galleries."
*Ceramics Monthly Magazine*

**Artists throughout history have struggled;
on the cover are photos of a handful of those
who did. Clockwise, from upper left.**

*George Bernard Shaw*
*Paul Cézanne*
*Alexander Calder*
*Tamara de Lempicka*
*A. Seddeler, D. Kardovsky, Vasily Kandinsky*
*Auguste Rodin*
*Pierre-Auguste Renoir*
Top Inset: *Emily Dickinson*
Bottom Inset: *Boris Kustodiyev*

# LIVING the ARTIST'S LIFE

A Guide to Growing, Persevering and
Succeeding in the Art World

Second Edition

*(Illustration, by R. Caldecott, shows an artist returning from a day's
work in Brittany; rendered at the time of Gauguin's colony there.)*

## PAUL DORRELL

Hillstead Publishing
Kansas City, Missouri

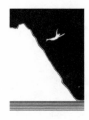

First Hillstead Hardback Edition, April 2004

Second Hillstead Paperback Edition, March 2005

*Copyright © 2004, 2005 by Paul Dorrell*

**www.hillsteadpublishing.com**

Publisher's Cataloging-in-Publication Data

Dorrell, Paul.
  Living the artist's life: a guide to growing,
  persevering and succeeding in the art world /
  Paul Dorrell.—1st Hillstead hardback ed.
  p.  cm.
  Includes bibliographical references.
  LCCN 2004100792
  ISBN 0-9749552-0-5 (pbk.)
  ISBN 0-9749552-1-3

  1. Artists—Life skills guides. 2. Art—Vocational
guidance.  I. Title

    N8350.D67 2004        702'.3
                          QBI04-200074

Cover Design: Kevin Brimmer • Typesetting: Dedra Earl • Logo: Richard Raney

Printed in the United States of America
on Recycled Paper

*For Annie*

# Contents

# *Foreword*

The artist Robert Henri said: "Art is a terrible way to make a living, but a wonderful way to live. . . ." In this book, Paul Dorrell helps us see that the artist's life is not only a wonderful way to live, but can also be a wonderful way to make a living.

For many artists, their profession is a mysterious calling, a way to create something unique while rebelling and living outside of society, yet never losing sight of the need to move society. Most artists must persevere against enormous odds in pushing their talent forward. For many, there are no rules or guidelines in the silence of the studio—and, more terrifying, no audience in the loneliness of the studio.

Dorrell gives practical and personal direction to this complex journey. Through his experiences as a gallery owner and novelist, he has been able to put into context the reality of an artist's life, and how to meet its demands. The issues he addresses, chapter by chapter, range from the emotional to the concrete in well-written and provocative prose. In other words the book is thorough, moving, and inspiring.

Dorrell has broken new ground here, and in doing so has been able to share the fruits of his successes and failures with us. I feel we are all enriched by the result.

Murray Dessner
Painter
Professor
The Pennsylvania Academy of the Fine Arts
Philadelphia, PA

# Acknowledgments

My wife Annie, for her enormous love, wisdom and insightful feedback. My editor Greg Michalson, for all that he does so well. Jim Leedy, Murray Dessner, Edie Pistolesi, Ken Ferguson, Doug Baldwin, Michele Fricke, Ralph White, Bob Brawley and Steve Whitten, for their kind support. Smarty, for making me a better climber, and for giving so very much. All the folks in Connecticut, for those fine years along the Farmington River. William Reiss at John Hawkins, for believing in my books. Ted O'Leary, for the same. My assistant Erin Holliday, for more than I can list. Julie Enwright, for the same. Jim Brothers, for Twain and all that followed. Patti Catto, for her profound criticism. Bob Fisher, for his kind counsel. Jim van Sickle and Dean Mann, for their uncommon generosity. Sam Anderson, for Prague. Steve Dickey, for the poetry. Tommy Geiger, for the paths. Dan Akkerman, for altitude sickness. Bowie and John Franey, for Blackwater. Geo, for the Olympic Range. Buddy Fuoco and Don Smith, for Lake Garda. Stive and Johnny Butler, for Low Chicago. Jeff Boring, for the bikes. Bill Kluba, for New York. Liam Daly, for Irish steadfastness. Kevin Brimmer, for layout rescue. My stable of artists, for their talent and loyalty. My clients, for their loyalty and checkbooks. Every librarian who ever helped me find a book. Byron Dickson, for D-Day. Larry Stout and Bob Lowry, for the c.c. My sons Denny and Josh, for all that we have given each other. My mother and father, for all that they gave me.

February 1, 2005
Kansas City

*"How short life is and how like smoke. Which is no reason for despising the living, on the contrary.*
*So we are right to care more for the artists than for the pictures."*

Vincent van Gogh, in a letter to his brother Theo.

# ONE

### *Stieglitz, Guggenheim, You and Me*

I am a gallery owner and art consultant, as I have been since 1991. In the business sense, the people sense, and the giving sense, I suppose I am considered a success. That's cool, but what I am first is an artist myself—a novelist. That is the primary passion of my life: driven, maddening, fulfilling, by turns sane and insane. Just as many of you couldn't conceive of life without painting, sculpting, drawing, or just plain creating, I couldn't live without writing. The only reason I got into the art business was to support my family on the road to publication, which says a lot about my initial naiveté in both professions. But I got into this business to succeed—regardless of all my early failures—and so undertook it with the same passion with which I write. I had to; otherwise I never could have helped my artists achieve their successes—regionally, nationally, and in some cases abroad.

Why have I written this book? To give you the opportunity to learn what we have; to guide you as you develop your career; to reassure you when it seems your career is in flames or, worse, when you feel you don't even have any freaking career.

In short, I'm here to help you succeed as an artist, and yes, that means in the world of commerce, as well as in

the universe of your own vision. The definitions of your success—whether monetary, spiritual, esthetic, or all of these—are up to you. My job is to reassure you that you can achieve your goals, and to help guide you to the point of their realization. This book, based on all my years of experience, as well as on the experience of my artists, can help you do just that. In some form or another, I've been immersed in the arts since 1980; many of my artists since the 1960s. You might say we've learned a thing or two in that time.

Is this book only for artists? Of course not. I've also written it for the student and the teacher, the writer and the reader, the gallery owner and the collector, and anyone else who lives within the world of creative drive.

What gives me the authority to write it? The fact that I've gone through the travails that many of you are facing, or are about to. I speak your language. More importantly, I've managed to succeed as an art dealer in a field where success is rare, and despondency common.

As I write this, I'm concluding contracts for commissioned works that total well over a million dollars. In addition, my gallery sells roughly $250,000 in paintings and sculpture to collectors each year. Is that big money? Hardly. In fact it's little more than chump change for those rare dealers who trade in the millions, whether in contemporary art or antiquities. But for peasants like you and me, these achievements are significant and quite real; they have allowed me to live the dream.

A list of some of our projects: an eight-foot monument of Eisenhower for the Capitol Building in Washington, DC; sixty-one works of art, most of them contemporary, for a convention center in Kansas City; all monumental sculpture for the National D-Day Memorial in Virginia; all monumental sculpture for the VFW's Centennial Memorial; a contemporary work in stainless steel for Mack Truck;

a monument of Mark Twain in Hartford, Connecticut; murals for restaurants and hotels, massive works in blown glass for hospitals and corporations, numerous paintings for private collectors, a variety of sculpted works for the same. Steven Spielberg has acquired work through my gallery, as did Charles Schulz, Air France, Lufthansa, Russell Stover Candies, and hundreds of others, both private and corporate, both wealthy and struggling.

Did any of this happen overnight? No, but through blind perseverance, the usual stint of hard work, and a series of mistakes (also known as opportunities for learning), it has all happened.

When I first started my business, I did so in a bout of blind enthusiasm, gullible ignorance, and uninformed optimism—like most gallery owners. It was only after I started it that I realized most galleries simply do not turn a profit. Every month new galleries open all over the world, and within a year or two most of those new galleries have gone broke. Even some of the most noted galleries of the twentieth century, such as Alfred Stieglitz's 291, never managed to run in the black.

Example: Stieglitz opened his space in 1905 in New York, and was forced to close in 1917. In the intervening years he introduced to America, with the help of Edward Steichen, the works of Cezanne, Rodin, Matisse, Picasso and Brancusi, to name a few. He also used 291 as a center of the Photo-Secessionist movement. Yet despite all of Stieglitz's many contacts, his relative wealth, and the thousands of people who went through the Little Galleries, he still couldn't turn a profit. Of course the business of selling avant-garde works was in its infancy at that time: the pieces were simply too far outside the mainstream to appeal to many collectors. As a consequence, Stieglitz had few opportunities for sales. He would amend this condition by the time he opened An American Place, his last

gallery, in 1929, but not without the help of many people, including his second wife, Georgia O'Keeffe. Otherwise, he would have lost money there too.

The same could be said of Peggy Guggenheim's galleries, the first in London and the second in New York. Throughout her years as a dealer, in the Thirties and Forties, Guggenheim sold very little. In fact in her first shows— for Kandinsky, Calder, and, later, Pollock—she sold nearly nothing, despite the wide acclaim the shows inspired. If it hadn't been for her policy of buying at least one work from each artist, those artists often would have sold nothing. Fortunately Guggenheim had very deep pockets, and could afford to run her gallery at a loss in a way that even Stieglitz couldn't. Eventually her efforts at promotion, and her contacts, helped carry the day for her artists, although most of them didn't realize the financial rewards until much later, long after she'd closed her second gallery. By that time, the art business in New York had boomed, but even then it tended to benefit only a select group of artists, and is still a highly risky undertaking at best.

The point is, with both of these dealers it took a very long time for success to be realized, whether for themselves or their artists; much longer than it normally takes for the average business to realize the same.

I faced many of these same problems when I decided to open not in New York, not in San Francisco, but in a provincial Midwestern city. Some of the work I carried was contemporary, some of it traditional, none of it radical—meaning, if all went well, that I should be able to find a ready market for it. My artists had dedicated their lives to their work; I knew that most of it was good, and that most of it had depth, originality, and passion.

I reasoned that surely I would be able to make a living selling work of that nature. I certainly couldn't afford to run the gallery at a loss: the needs of my family, and artists,

didn't allow for it. Nor did I have deep pockets to fall back on. The only thing I had was my wits, a modicum of sense, and a willingness to work bloody hard. I took confidence in that, but those qualities still were insufficient to keep me from going deeply, very deeply, into debt.

Later, when the realities of the gallery business came crashing down on me, I was in too deep to honorably quit. Like Stieglitz, I had to succeed. So, this being America, I decided I could.

How did I do it? Easy, fraud.

Just kidding. The truth is, the path to success for my artists and me was arduous, demanding, despair-ridden, and constantly threatened with financial disaster. At the same time, walking that path has been one of the most rewarding achievements of a life that already was very full. It's given me a great deal of pleasure, a number of headaches, and countless challenges. But if I can't take pleasure at least half the time in my work, whether selling art or writing, then I know I'm doing something wrong.

Over the past several years I've taken a select group of artists, and have helped establish national careers for most of them. None of them is as yet a household name in the arts; they may never be. But each of them is making a comfortable living, each has matured dramatically in his or her work, and each is as indebted to me as I am to them. We've done it together—agreeing, disagreeing, and occasionally raising a little hell. I suspect that most of us will finish together too.

In this book I'll explain to you how we went about this. I'll do it with drama where appropriate, telling stories of compassion, anger, understanding, dissipation and love. But I'll also do it with practical advice and simple guidelines that will help you achieve what we have. And don't think you can't do it, because if you really want to—if you're willing to pay the price, and make the sacrifices, and work the hours—then you can.

In art school your talent is cultivated, your medium chosen, your direction established. But afterward, who teaches you how to get your first exhibit? How do you even know when you're ready to exhibit? How do you gain acceptance into the galleries? How do you survive in the meantime? How do you deal with all the emotions boiling inside you: the uncertainty, the loneliness, the highs and lows, the insecurity, the longing and the rage? How do you keep these things from destroying you during the bad times, and how do you sustain the brilliance during the good? And do I honestly believe that I can help you with all this?

In some measure, yes. I've done it with myself, with my artists, and many others. I'm no sage. I'm certainly no great man. But I do know art, I understand artists and the art business, and I very well know the artist's life. I observe and live it every day. I was born to. I also realize, as most of you do, that art—music, painting, writing, sculpting, being—is a cornerstone of any civilized society. My function, and yours, is every bit as significant as that of the teacher, the farmer, the legislator, the mother. Those roles are all interwoven, not one of them more substantial than the other, but each with its own enormous responsibility. We are here, you and I, to make sure that society never forgets our place in that roll call.

So read the book. Use it as a guide for whatever vision burns inside you. It will help you from the day you decide to be an artist, to the day you realize you are one—if only in what you do for an everyday living. I've been down that road, I know my subject, and I'd like to impart some of that knowledge to you. In the end, of course, the fate of your career will be largely up to you. But as you go down whatever road you've chosen, let me go with you. Let me give advice where I can, with you taking what you want, and disregarding what you choose. You won't lose a thing from what I have to say. To the contrary, you'll only gain.

So let's get started. Yes the road is long, but I can't think of any other I'd rather take, or any group of people I'd rather take it with.

And for those of you who aren't artists, but are drawn to the arts, I've written this book so that it will relate to your lives as well: your passions, your dreams, your quest for a fuller life. Certain sections that cover practical issues you can skim, but I don't advise you to skip anything. You'll likely be drawn into the work overall, especially when I address issues such as inspiration, insecurity, love, humility, depression, perseverance, thoughts of suicide, thoughts of glory. Then there is my own gallery's story, my navigating the waters of both the publishing and the art world, and the course that brought me here. In the end, I think you'll find that the journeys, hardships, and victories I discuss will have parallels with your own, may even shed light on your own.

So read the book. It's brief enough. After you've finished, hopefully you'll come away with a better grasp of the art world, and why that world is so crucial to yours.

It doesn't seem crucial? Sometimes it even seems absurd? Sure it does, or at least certain aspects of it do. It always has. Even I get sick of it on occasion: the pretension at certain openings, insecurity masquerading as snobbery, sycophants drooling all over work that anyone can see is a joke, the same inane conversations over the same glasses of wine. I know all that, but that isn't the true art world; that's the facade. The true one is made up of hardworking artists who, in the end, are just people of the earth, and who hate pretension as much as you and I do.

I'm here to help you understand that, and to cut through all the crap—which I love doing. By the time you reach the final page, I suspect you'll begin to see the world of art, and the dreamstate in which it thrives, as being as crucial to our society as the right to vote, the right to freedom

of expression, and yes, even the right to pursue happiness—an American concept if ever there was, but a noble one.

### Now, Let Us Begin

All right, so you're soon to graduate from art school, if indeed you haven't already. Or maybe you never did graduate but just dropped out; maybe you wearied of what all those professors were trying to teach you, and just wanted to dive into it on your own. Or maybe art school was twenty years ago and you're only now picking up where you left off. Or maybe you don't want to be an artist but simply want to live the artist's life. You want to create. You want your life to be your canvas. It can be. It should be. For all of us this should be so. For very few, it is.

But in some sense, you've graduated. Now what?

Assuming you've acquired the necessary background in painting or sculpting or printmaking, or maybe a smattering of disciplines, do one thing first: congratulate yourself. It wasn't easy. It cost a struggle of emotions and finances and loneliness and exaltation and despair and odd alliances and odder rivalries but, in the end, it should have brought you closer to your calling. If it didn't, don't worry, time and hard work will do that. Time alone may do it, but not in the way that work will.

Self-discipline, as you surely know by now, is far more important than trying to glide along on whatever level of talent you were born with. Learn to rely on the former and to utilize the latter, but never assume that your talent alone will win you your successes. Hard work will take you much further down the line than mere reliance on brilliance will, whether that brilliance is real or imagined. In fact it's astonishing to me how often an average talent blossoms, over years, into earned brilliance, while born brilliance often recedes into mediocrity.

Anyway, in some form you've graduated. Now what?

You can travel, if you have the means, and even if you think you don't. You can go to Europe; you can go to Asia; you can go to the Middle East; you can go to South America; you can go anywhere you want. It's all a matter of preference, and inner desire, and the need to explore places that intrigue you, places that feed your art.

Let's say you choose Europe, as I have twice now. Yes you can still go there cheaply and live out of a backpack, tour all those great cities, taste of all those wonderfully diverse cultures. If you can, you should. Do it now. It can also be done later. If things go well it can be done several times later, but it will never again be as simple as it is right now, while you're so young. It is good, when fresh out of college, to go to older cultures and learn what they have to teach you. It helps you set your bearings straight before starting the larger journey. And setting the bearings correctly now is far easier than adjusting them later, in midstream—even though most of us are compelled to do that, often more than once.

So go to Europe if you can. Let the Europeans humble you. They're good at it, and enjoy doing it. Then when they're done, ask them if they remember Harry Truman and George Marshall, and their reconstruction plan. Marshall and his peers helped pull the western Europeans' butts out of the fire during World War II, and during the reconstruction after, when those same Europeans had nearly nothing left, having collectively, through the absurdities of the Versailles Treaty, brought on a war that destroyed a great deal of their continent, and damned near their civilization. And while it's true that we may owe them much, gently remind them that they owe us too. That's what makes the relationship work.

But maybe you can't go overseas now. I couldn't either when I finished college: I was simply too broke. So I wandered America instead, eventually covering every state in the union. If this is your only option, then forget other

cultures for awhile. Believe me, there's plenty to see in this country: its vulgarity, its beauty; its greed, its generosity; its violence, its compassion; its appalling ignorance, its stunning levels of enlightenment. It's a country of extremes, and to know it you must accept those extremes, and all their contradictions, and their wonder too. Also it is a country of many fine museums. Visit them. Visit as many as you can. And don't tell me you can't, because you can. How else will you see the masters? Who else will you compare yourself to? How else will you rate your own work?

Go to New York, Minneapolis, Chicago, Los Angeles, Seattle, St. Louis, Denver, Dallas, Washington, New Orleans, Miami, Kansas City and anywhere in between. No matter where you live in the contiguous forty-eight, there are fine museums within a day's drive, and many smaller ones within a few hours. Get to know them.

You can't afford a motel? For a long time I couldn't either. That's why, in my early days, I did all my traveling by motorcycle, often sleeping in a tent at the edge of each city, or in the apartments of friends. Lord the scenes I witnessed, the people I met—both maniacal and kind— and the experiences I immersed myself in. That bike was a cheap and incomparably stoked way to get around, although of course I had to accept the risk of possibly getting killed on any given day. For some people that risk is worth it; for many it's not. Me? It was the only way to see Key West at sunrise, Hollywood Boulevard at sunset, the Olympic Peninsula in full rain, and Cape Cod in summer. For me, at that time, it was the only way to really travel, and understand, this country.

In later years, when I had all kinds of art to lug around, I slept in the back of my aging minivan—always in a safe part of each city. I don't advise that you necessarily do the same, but if you're streetwise and know how to do this

without setting yourself up, it will allow you to eat well, and to spend money on worthwhile things like books, decent meals, and gifts for loved ones.

Driving any place is an adventure. America is a land for driving. Enjoy the privilege while we have it. Dig on the old architecture, the old barns and farmhouses and train stations. Dig on the small towns, on their tranquility and simplicity and on their limitations as well. And never cross a major river—the Ohio, the Mississippi, the Columbia, the Hudson—without once stopping and standing at water's edge, trying to behold all that has passed there, and all that is yet to. Toss a coin in it. Toss a rock in it. Pee in it if you must. But most of all feel it, and the life it speaks of. Then rejoin the masses of cars on the interstate.

When you get to the museums, study the masters— and I do mean the old ones. Study them well. Study the traditions and try to learn what they have to teach you. Never mock a traditionalist unless you can do better, and don't mock them even then. If your leaning is avant-garde, or deconstructionist, or sheer abstraction, that's fine, but it will behoove you to understand, and to even try to execute, what Sargent did, what Rembrandt knew, and what Michelangelo mastered. After you do understand it, then you can move on to Rothko, Warhol and de Kooning. Why? Because it is impossible to grasp where art is going if you do not understand, and respect, where it has been.

If your work is all social statement and no craft, that's fine, but you may want to ask yourself, what exactly are you offering the world that no one but you can execute? As an artist, this is one of the most important questions you can ask. And yes, you eventually must answer it, since if your work isn't unique, if it doesn't reflect a vision and a discipline and a vigor that in turn reflects your individual talent, then what's the point?

I don't care which museum I may visit—the Chicago Art Institute, the L.A. County, the Met, the Nelson—I personally never try to tour all of one museum in one day. That's too exhausting. Instead I simply gravitate toward the work that I'm interested in at the moment, and when I find those rooms, I may well spend hours there. Maybe I'll sit, maybe I'll walk in those ridiculous circles that we all do in museums, maybe I'll initiate a flirtation. Whatever the case, I never push myself to view more works than my senses can appreciably take in.

And as I'm looking at those works, I try to never forget that the paintings on the walls, and the sculptures on the lawn, were each the same product of insecurity, ego, humility, joy and depression that most work is. The artist who created those pieces—whether Duchamp or Motherwell or Moore—had as many difficulties, and was as full of piss and vinegar, as the rest of us. Sometimes their difficulties were greater than anything we can imagine, such as Rodin during his starvation years; it's just that fame, and the passing decades, have dulled the bitter realities of that sacrifice. But believe me, the hardships were just as real and harsh to the young Rodin and his family as your own are to you.

Remember this too: most museum works were created in sloppy studios under all kinds of duress, and often were the sole thing of beauty in those distant, ill-kept rooms. Sometimes those works were the only thing of beauty in many of those distant, tragic lives. The formal surroundings that they now hang in don't change the conditions of their creation, they just change the background, and the background is often deceiving.

In the same vein, the museum intellectuals who analyze those works, and dissect and explain them, and in some cases worship them, don't change their essence either. Those intellectuals, while essential to the museum business, are

not made of the same cloth as the creatures who created the works; the two are different breeds. Normally the intellectuals know this, accept it, and often are glad of it. If they don't, don't disillusion them: everyone should be allowed their bit of fantasy.

More often than not the artist is not an intellectual, does not fully understand what she creates, and doesn't even want to. The artist, in all probability, would never fit into a museum staff job; she can't fill the intellectual's shoes, just as the intellectual can't fill hers. But they need one another. We need the intellectuals to preserve and explore the work, just as we desperately need all you haphazard artists to render it. The relationship is mutually beneficial.

Keep all this in mind in the museums as you tour them. Don't ever let a museum, or its staff, intimidate you. If it weren't for your kind, there would be no need for art museums, or their staffs. Just as importantly, never let a museum kill what the work is about, since some of them, with their excessive formality, do. See the work for what it is, and how it was created. And always remember this: you are of that family. But try to not take that for granted; chevrons are earned, not given.

So tour the museums, tour the towns and cities; take in all you can of the past and present, and the future too if it speaks to you. Let no experience pass that thrills you, or scares you, or challenges what you think you know. Live fully but not destructively, unless self-destruction is your credo. If it is, that's your business, just don't take others down with you. That isn't your due. Creation is your due. Respect that. Let it anger you if it must, let it enrage you on occasion (apologizing later to those you offended), but keep your fire alive, so long as you don't rely on dope, booze or abuse to do this.

Many people think they keep the fire alive with the dope and the booze, only to find out years later that they were

extinguishing it all along. Then they find out it's no longer able to be rekindled. Then they die. You can do this too if you want, but what will you accomplish in the course of your deterioration? Very little, either for yourself, or for the society whose attention you're trying to gain. And yes, we all do it partly for attention. Sure, we do it for the passion and the inspiration and the desire to give, but attention is one of our primary motives, so you may as well go ahead and admit it, if for no other reason than to get it out of the way. (Just don't try to get me to admit it. I've never done anything for attention. Oh never!)

All right, a select group of museums are behind you. Now you have to get back in the studio, and back to work. You have to engage your passions. Yes, painting and sculpting, like writing, are an "engagement" of sorts. They are an engagement between the butt and the chair (to paraphrase Hemingway), or the hand and the brush, or the lips and the blowpipe. Nothing takes the place of hard work. Nothing, you will find, has as much bite either.

# TWO

***Why on Earth Did You Choose this Profession?***

You didn't, it chose you. Or you chose it prior to this life. Or it's something leftover from a future you've yet to experience. Or maybe you don't buy any of that stuff, and it's simply what you want to do. Or maybe you're just nuts. Either way it's all good, and sometimes bad, but mainly it's good—if you want it to be.

Get ready, the journey is long. You think your work will be ready to show to the galleries in a year or two. It won't be, but you have to believe it will. You *must* believe this. And that ego that sometimes made you ashamed in college, for perhaps being too cocky or too self-sure or just plain arrogant—don't toss it away just yet. You'll need it. You'll need it to bear you through the privations and rejections and periods of self-doubt, and the endless rounds of depression-elation that you're bound to go through.

But I do advise that you tame the ego. Let it serve you, just don't let it make any more a fool of you than necessary. Eventually your work, and your confidence in it, will speak for itself anyway. You and your ego will have nothing left to prove. And if you never went through that in the first place, be grateful: you're rare.

Example: I wrote my first short story in college, when I was twenty-one. After I turned it in, the professor singled

me out—as my ego fully expected him to—and said that mine was one of the best stories of the year. The bad part was, I felt certain he would do this. The worst part was, my fellow students knew I felt it. In my quietly confident way I had broadcast to them as much. And the whole time I was thinking, man, this is going to be easy. The *New Yorker's* next, then an agent, then Scribners. Faulkner and Twain rising from their graves to welcome me into the fold.

The truth: all twenty of my succeeding short stories were disappointments. In due course I was humbled, and my ego quietly climbed into the back seat.

Still I kept writing, starting my first novel in a friend's cabin in Connecticut when I was twenty-five. It took me two years to write it. That book was a disappointment too—in fact it sucked— but at least I finished the freaking thing.

The struggle with that book changed me; I matured maybe a little, and began to understand how to better wield my talent. Six novels and fifteen years later I landed an agent, and felt at last that my foot was in the door. Somewhere during the course of that journey I found satisfaction with the work instead of with the warped dream of fame. My wife, often more mature than I (no surprise there), helped me learn this, while I in turn helped her to live more fully. Our kids, by virtue of the simple demands they place on parents, helped me too. For their sake, and my own, I *had* to succeed—however one may define that.

Along the way I emerged from self-pity and rage (lord, some of my rages), my darker depressions, my occasional thoughts of suicide. I accepted my fate, accepted that I was in this for the long haul, and stuck with it out of sheer passion. That was hardest to do in the beginning, since it's very hard to stick with something you're not yet good at. But if you trust your inner voice, or maybe just your own bullheadedness, you'll know you're sticking it out for the right reasons. If that intuitive song sings true to you,

then no one else's opinion—parents, lovers, critics—should matter. Later, when you're more open-minded, qualified opinions about your work *will* matter, and you'll have to learn to listen to them. But in the beginning, stick to your intuition, even if is partly ego-driven. Often it will be right when everyone else is wrong, including you in your deeper moments of self-doubt.

In my case, from that day in 1980 when the professor singled me out, to that day in 1997, when one of the most esteemed agents in New York called and said he wanted to represent me, it was a seventeen-year journey of all the highs and lows that such journeys are made of. I knew that call wouldn't earn me a book contract overnight, but at last it seemed I was on the verge of publication, and could finally offer my family a modicum of financial security. That, anyway, was how it seemed.

As it turned out, that agent never got me a single contract. After four years of increasing discouragement— despite some of the critical acclaim my work garnered—he and I parted ways. Afterward, the darkness of failure again began to cover me. That darkness, with me by then in middle age, lasted a full year. How, I thought, with all my debt, with college looming for my children, and no retirement plan, would I persevere now?

Here's how: lack of choice. It was either persevere, or give it all up—and giving up was unthinkable.

So I regrouped, counted my blessings, and set about writing two new works (despite the fact that I *knew* the old ones were fine). The new works gave me renewed life, as though a second phase of youth was passing through me. I knew now that nothing could stop me, that my work would eventually find the light of day—whether during this life or after—and that all would be taken care of. I only had to live well and write hard, and write better. I suppose I had to accept the rewards inherent in *that*, before I could

LIVING the ARTIST'S LIFE

accept the more mundane, and frankly less important, rewards of a book deal. Odd, how the more I improved as a writer, the less important the deal seemed.

So yes it's been a long struggle, but the greater the struggle the greater the rewards—especially internally. Of course the length of my struggle can largely be attributed to the fact that I'm a slow learner. For all of you it will probably go much faster. It may never go as fast as you'd like, but that's good. Learning patience is a virtue; trying to circumvent it is not.

So, why did you choose this profession? In all likelihood you didn't. Like me, you were born to pursue it with all due vigor, damning the torpedoes as you left shore. Good. I applaud your recklessness. Now, did you remember to bring a life preserver?

### Conformist or Nonconformist?

An artist can be either. There is no written rule that says you have to be radically dressed, tattooed and pierced, and to the left of center in your politics to dwell in the art world. All you have to be is open-minded. If you can't be that, at least be bloody good at what you do. Chances are though, if you were born an artist you were also in some measure born a nonconformist. This is something you won't be able to help, and shouldn't want to.

Grandma Moses, in her quiet way, was a nonconformist. So was Whistler (God rest his turbulent soul). So were Martin Luther King and Henry David Thoreau, for that matter. So am I. I view life in my own untypical way simply because it's how I see things, or have brought myself to see things. But that view hasn't been arrived at haphazardly.

For me, I consider it one of my obligations, through my writing and gallery, to urge society to question itself, its direction, its purpose. I enjoy doing this, although it has a tendency to cast me beyond the pale. That's fine. The artist

*18*

is supposed to live beyond the pale, to be something of an outcast. At first this may anger you. Later, if you use good judgment, you'll see the need for it, and the anger will slip away. Let it, although there's nothing wrong with letting the anger back in once in awhile. Good work can come from that emotion if taken in doses, but self-destruction is more likely to come from it if used in abundance.

## Drive

Where does this nebulous, hard-to-explain, harder-to-define quality come from, and what is it that, well, *drives* it? I haven't a clue. Is it essential to what you do, and to your eventual success? As essential as your talent. How will you know if you have it? Because of the way it rides you, rarely letting you rest, never letting you forget your calling, or your duties to that calling—even after you've achieved everything you wanted to. Drive is merciless, ceaseless, and, in the worst cases, heedless. I ought to know: I've been guilty of my share of all that.

My own drive is never-ending. I have no choice but to write. If I don't, then I don't feel fully alive. I feel as though I'm skipping out on some obligation that is bigger than I, and that I was put here to carry out. I also begin to feel like my emotions will explode if I don't do the work that releases them. Does this mean I'm greatly talented? Hardly. Does my drive make it any easier to face the blank page each day? It hasn't yet. Does it give me confidence, even when the substance of my work fails to? Almost always.

Do you need to feel that same drive in order to pursue *your* work? On some level, yes—that is, if you plan to mature as an artist. It can be a mild sort of drive, it can be harsh, it can be virtually insane. But you *must* feel it in some measure; it's partly where your inspiration comes from. You should also be grateful for it, no matter how high the price you sometimes pay for bearing it, since without

that drive, you wouldn't fully be an artist.

What if you feel no drive at all, but simply enjoy working in whatever medium calls to you? Then I've one word to say: congratulations. You're free of a terrific burden, which will in turn leave you free to simply take pleasure in whatever it is you do. After all, it's not required that you be a tortured maniac in order to pursue your work. But if you're trying to reach the higher levels of that discipline, being tortured, as well as something of a maniac, can be a pretty handy thing—if you know how to deal with it.

*How* do you deal with it? Like most things in life, by making mistakes, and taking the time to learn from them. Get ready, you'll make plenty. But then, think of all the lessons you'll learn.

## Suffering

No, we don't suffer more than other people. What a lot of nonsense. We do, however, tend to feel things more deeply. This, combined with our inordinate sensitivities, seems to make the suffering more intense. Couple that with the usual insecurities, spells of depression, and years of rejection, and baby you've got one suffering artist. Or to quote good old Scott Fitzgerald: ". . . There are open wounds, shrunk sometimes to the size of a pinprick, but wounds still. The marks of suffering are more comparable to the loss of a finger, or of the sight of an eye. . . ."

He wasn't lying either, since that dude suffered greatly—not necessarily because of what he went through, but because of how he took it. His wife Zelda too for that matter, although some claim that by the time she died, in that horrible fire in the asylum, that she didn't feel those kinds of things anymore. Maybe she didn't, but I'd hate to be the one to speculate on the nature of her emotional state when the flames finally reached her.

Will you suffer? As surely as you eat, drink and breathe.

Will your work benefit from it? If you choose for it to. Is this a necessary condition of being an artist? I don't know about 'necessary,' but I can with authority say that it's a common condition of our existence.

All right, so we suffer. But by God, we know how to live too. And by *we* I don't mean just artists, but anyone who lives sensually, and through the power of their creativity—whether in the art world or the corporate world. Few people are given the gift to live in this way, few people are able to feel so fully alive between the spells of suffering. That suffering is merely a part of the price you pay for your talent, and since you have to pay it anyway, I advise you pay willingly. The alternative is to live an unenlightened existence. I ask you, isn't that a common enough condition already? And aren't you glad it isn't yours?

### Inspiration

I'm a fool to even try to address this, but I know I must.

Inspiration is largely an inexplicable thing, since it tends to come from different places for different people. I can't tell you how to gain it, how to maintain it, or how to renew it. But then you shouldn't need me to, since you'll likely know this for yourself.

For me, it tends to run like this: New people who intrigue me; old friends I adore. Riding my Harley at night through rough parts of the city. Inline skating for miles on a July afternoon. A series of tough climbs at the rock gym. Four belts of whiskey on a Saturday night when I should restrict myself to two. No whiskey on other nights. An arousing flirtation. Great music, any kind. Great books, any sort. Teaching my children to play soccer, or baseball, or simply how to give. Telling them I love them, telling my wife the same, but more importantly proving it. A hot night of hard sex where mild pain is as fine as the ecstasy. A cool night of gentle sex, where all is sensitivity and tender-

ness and warmth. Several nights without sex, since that act must remain special. A sunrise in summer; a sunset in fall. An old movie with my family, a walk in the country, or a drive to see the old folks. Backpacking in New Mexico, strolling through San Francisco, canoeing in the Ozarks. Dinner together on a Sunday evening, where the kids ask all manner of questions, and my wife and I try to answer. Making a sad woman smile; making an angry man do the same. Entangling myself in an involvement that could possibly destroy me.

The list just keeps going. Everyone has their own style, and mine likely couldn't be more different from yours. Find your own then. Find what keeps you alive and what keeps you challenged. If you do not renew the challenge, both internally and externally, you will go stale. So will your work.

For me, my inspiration is at its best when I can weep. I don't mean publicly. I mean when my writing brings tears to my eyes, or some piece of music, or the thought of some old family tragedy. The tears mean my emotions are fine tuned, and if my emotions are tuned, I know I can work well. If they're dull and flat, if I'm going through one of my periodic two-month depressions, then I have to try to work well anyway. You *have* to keep working, even when you don't want to. You have to work through your depressions, your bouts of loneliness and dejection and despair. The work might be abysmal during these times, but it might also be great. Don't rely too much on inspiration. Rely on day-in, day-out discipline. That will bear you through. Dreaming will not, but it's an important part of the process.

Wherever your inspiration comes from, whatever you must do to keep it stoked, do it—as long as what you do is reasonably sane. Like drive, talent and discipline, you must maintain this most mysterious of the artist's

traits; it is an essential part of your makeup. Without it, just as without the other traits I've discussed, you'd not only be directionless, you'd be sunk.

### Are You Selfish?

You'd better be: I hate to say it, but you'll need that fault for awhile. This common but ugly trait, along with your ego, will help sustain you through your initial years of struggle. As those years fall away, you'll hopefully learn to moderate your self-absorption, and to temper it with a more balanced attitude. But likely the selfishness, to some degree, will always remain. Without it you couldn't work as well, or with the devotion you'll need to bear you through the periods of failure and rejection.

Eventually, if the work becomes good enough, and your confidence strong enough, the selfishness may evolve into something different. You may find yourself spending time guiding younger artists, or teaching underprivileged kids, or, if you're meant to have them, guiding your own children along their way, realizing that helping them with their little victories and traumas is far more important than anything you'll ever create. Oddly, realizing this often allows you to create even greater work. It's one of those strange contradictions of life, but a very good one.

So sure, just as a secret between you and me, go ahead and keep certain aspects of the selfishness, but more importantly, keep them in check.

### The Bohemian Life

This lifestyle is much overrated. It doesn't tend to produce great art so much as it does the people who understand it, talk it, and live it—or try to. You'll have to taste of this world to know where you fit in, or don't, or whether you even care. Life in the cafes, and along the endless trail of gallery openings, can have its charms, but you'll likely

find that the people who attend so many openings, and adorn so many cafes, create very little work of substance. Many of them create nothing at all. They hang out in the cafes, they hang out at the openings, and in general enjoy themselves—or don't, depending.

Either way, these folks—whether they be dilettantes, bohemians, or both—are essential to the art world. They help keep it vibrant, they help keep it alive, and while they almost never can afford to buy any of the art they adore, they help keep the openings interesting. Besides, who else will latch onto your work with such devotion and interest? If a group of them take you up, and talk you up, that's good. They help spread the word about new talent, and they genuinely admire what you do with all the passion of someone who almost could have done it, but for whatever reason didn't. Who knows? Maybe they're simply too content to bother with such a struggle, or with trying to get the world's attention. I, with all the shuddering insecurities that first fired me out of the art cannon, can certainly appreciate that.

The point is, you'll have to decide which you are— a dilettante or an artist. Normally the two are different, albeit similar, breeds. If you are the latter, you'll find you're far better off in the studio than the bars, since the studio will in the long run give you gratification, while the bars will only give you a headache. That isn't to say you can't hang out in them on occasion, but you'll have to decide which place is more important to you. As with most things regarding your work, there will be little to decide, since you'll likely know the answer intuitively, or instinctively—or cerebrally if that's how you work.

Speaking of intuition, is it important to develop that sense as a guide, and to follow it wherever it leads you? It is critically important, but only if you have an inner voice that speaks to you. For those of you who don't, or who

don't believe in it, then don't bother; follow whatever it is you believe in. But if you *do* hear that voice, as I feel most artists do, then by God be sure to listen. Once it is finely developed, it can become an unerring guide through the unending maze of life.

## Dope

If you haven't quit this crap already, I advise that you do. It doesn't matter if it's weed, hash, coke, ecstasy or whatever, you'll never get fully in touch with your artistic power as long as you indulge. It limits your growth, limits your vision, and in general will make you depressed and lazy. Eventually good work, with a full life, should be all the high you'll need. You don't believe me? Look at some of the middle-aged people you may know who still get high. Look at the limitations they've placed on themselves. Look at their lack of discipline, originality and vision. Then ask yourself if that's where you want to be in thirty years.

Many of my friends became manic dopeheads when I was thirteen, in 1970. By the time I was fifteen, many of them were addicts—whether of heroin, coke, or weed. Me? I realized I would never become any kind of writer, or man, if I had all that ganja hazing my brain. I kept my distance from the insanity. Many of those same friends, to this day, never have quit, and it's disappointing to see how these people, now in their forties, have grown so little, and often lead lives so vacant. Loving many of them as I still do, it saddens me too. But they've made their choices, and I've made mine.

The world to me is too mysterious and full of possibility to cloud it with such voluntary absenteeism. You couldn't *pay* me enough to get high. You could pay a great many of my old friends though, and they'd run right out and buy another spleef.

This isn't to say that I'm more virtuous than they, or without my own vices. It is to say, though, that I'm able to contribute far more to the world than I would have otherwise. And I've inherited too much responsibility, as I feel we all have, to believe that I can carry out my vision from within a cloud of cannabis. Maybe you can—Carl Sagan apparently claimed he did—but that would make you different from all the other dope smokers I've ever known, and I've known a few.

## Booze

This is the same as dope in many ways, and often just as bad—if not worse. This, by the way, *is* one of my vices. I don't drink hard, I normally drink only on the weekends, and then I try to restrict myself to two or three drinks a night. Sometimes I fail at this; most of the time I don't.

I have a few drinks in one of the cafes, my wife and friends have a few drinks, we go home, I wrestle with the kids, later wrestle with my wife (if she's so inclined), sleep, and wake up the next morning with the sensation gone—as long as it was just a few drinks.

When it becomes five or six or eight, that's different. The gray cells start to die off, your body suffers, your memory suffers, the hangovers become a daylong hell, and before you know it, a habit at least as destructive as any other drug begins to form. That's why I only drink moderately, and only on the weekends, although I didn't used to.

I know I'd be better off never drinking, but God that sounds so boring. Good bourbon, good wine, or just a good cold ale are things I've always relished. And I'm just stubborn enough to believe that this vice, in moderation, will never be as debilitating as the drug vice.

Do I contradict myself? Very well then, I contradict myself.

## Depression: The Artist's Malaise

Not until I was well into my thirties, did I realize that I had been suffering from some form of depression since childhood. Depression was so much a part of my nature that I never bothered to examine it, or its causes in my case. Instead I simply assumed that it would be my life-companion, that I was something of a freak, and that I'd just have to make the best of it. I hadn't known anything different, and therefore had no reason to believe that I would ever experience a life lived otherwise. On top of this I was a bit neurotic, being a writer, but that seemed to level out over the years, as have many of my insecurities. As a writer, I've had the advantage of working out my problems through the millions of words I've written. Not everyone is so fortunate.

Well I'm not a freak, and never was. Neither are you. The truth is, most of us suffer from depression in one form or another. For some it's merely an occasional bout, fleeting and brief; for others it's of greater duration, making even the simplest tasks onerous; for still others, it's so crippling that it makes life itself an impossible burden. Coming from a family of two suicides and its share of emotional illnesses, I suppose I know a little bit about depression of that severity.

In comparison to people who are severely, or clinically, depressed, my own case would have likely been considered mild. It never seemed mild to me—hailing from the background that I did, and the virtually insane adolescence that I experienced—but that's because I was the one living it. It's also because I, in my youthful bouts of self-pity, often believed that my life was hard to the point of being unendurable. Of course I had a lot to learn about that which is truly hard, and all the things that actually are endurable.

Does this mean that my difficulties were easy? No. There is nothing easy about emerging from a tortured youth,

writing in obscurity for twenty years, with almost no one to believe in you but yourself, and still raise a family, run a struggling business, juggle the threat of bankruptcy, care for all the people you must, daily battle your darknesses, and nightly gain what rest you can. That isn't easy. *Life* isn't easy. If it were, we wouldn't learn a thing in the process of living it.

But there are certainly worse conditions to live under, and those are endured by the bulk of the world's people, in the bulk of the world's nations, every day. In comparison to those impoverished conditions, as well as the misery that so many people endure in our own country, yes, my case was indeed mild.

When did the depressions first begin for me? I think when I was about eight, when I first realized I didn't really fit in (as most artists don't), and was terrified that I never would. By the time I was thirteen, this condition made me feel unworthy. By the time I was fifteen, it, and other difficulties, drove me into bouts of erratic and destructive behavior. By the time I was eighteen, I'd resolved to deal with my shortcomings through hard work, aggression and arrogance. By the time I was twenty-one, I realized that the arrogance had backfired too, that I'd driven away most of my friends, seemed incapable of making new ones, and felt farther than ever from finding my place in the world. I couldn't carry on a conversation, couldn't seem to snap out of my inner darkness, and didn't feel truly alive. What I did feel was unwanted, untalented, and without purpose. My depressions deepened.

This led to my first breakdown, which I experienced in college. I still remember the hallucinations, the killing despair, the inability to get out of bed, to eat, or to even answer the phone. Any thought of going to class wasn't entertained, but thoughts of suicide certainly were. (That is until I read Nietzsche: "The thought of suicide is a great

consolation: by means of it one gets successfully through many a bad night.")

Why didn't I take that final step? I guess in the end I realized I just wasn't made that way, and decided to try to accomplish something with my meager talent instead. So I finished with college and hit the road, structuring no career beyond that of the wandering artist, throwing everything I had into the writing basket. Unwise move? Perhaps, but ultimately there are no half-measures in art. It's either all or nothing. That's part of the insanity of it. It's part of the beauty too.

That first breakdown shadowed me, and everything I did, for two years: it followed me to California, Alaska, and Connecticut, forever with me, never letting me relax. Then I had my second breakdown, in a dark winter in a cabin in New England. I won't go into what happened that time, or how long it lasted, but a friend helped coax me out of it, and eventually taught me something about the worth of bearing one's burdens with a certain stoicism.

That was in 1983, and that was my last breakdown. Now? I suppose I've been humbled too much, have accomplished too much, love life and art and people too much, to ever go down that road again. I've learned the essential trick of never taking myself, or my problems, too seriously. I've learned to approach life with humor, and gratitude, as well as with a determination to never let personal events, or disasters, destroy my essential optimism—an optimism that has been earned through, and tempered by, considerable adversity.

How did I manage to leave the darkness and come to live in a world of light? I'd love to tell you that story, but that would be a book in itself. Besides, I've never fully defeated my depressions; I suspect I never will. At least twice each year I still go through a pretty bad bout, and each time it lasts for a couple of months. But from experience

I know that the depression will eventually lift, and that I only have to be patient, and keep my artistic vision intact, in order to emerge from it. It helps too that I have many people who count on me, and who look to me for guidance and kindness. I suppose you could say that many of those people love me, but the only reason they do is because I've worked so hard in giving to them—a thing that I value even beyond my work (well, *as much* as my work, which is going pretty far for an artist).

Why have I told you all this? Because I want you to know that if this is one of your difficulties, you're far from alone. Depression is a common malaise, even more common among artists. I mean look at what you're up against: nobody needs your work; when you're unknown, no one wants it; for years you'll struggle to emerge from the amateur level to the professional, and even then people will be largely indifferent to the thing you create; you'll have to surmount enormous odds to ever make a comfortable living from your work; you can't walk away from it because it won't let you; you *have* to create, even if it kills you; and the whole time you're trying to give this gift of wonder to the world, the world doesn't hear you because it, for the most part, doesn't speak that language. Who the hell wouldn't be depressed?

But take heart. Consider how fortunate you are to have your talent and vision, when many people don't even know the deeper meaning of vision. Consider how fortunate you are to feel alive. *That* is nothing to be depressed about. That is cause for jubilation.

I know there is no general prescription for everyone's private nightmares, and I would be a fool if I believed I could assuage them through the writing of this simple tome. Still I urge you to solve your difficulties as best you can, whether on your own, with the help of a therapist, or just the support of those who are close to you.

By doing this, you'll grow stronger. From inner strength comes good work. Good work can also come from suffering, loneliness, heartbreak, and anger, but in the long run the best work will come from inner strength. Strive for that. You can attain it if you're willing to pay the price of earning it.

### *Neurosis: The Artist's Badge*

This ties into depression, but must be addressed separately. I'll be brief, since it's more important to focus on your art, the creation of it, and the eventual succeeding of it. The difficulty is, I can't fully do that without first covering these related subjects, and doing so candidly.

In my opinion, the larger portion of our planet's population is, in some form, neurotic—whether mildly or severely. This naturally includes artists. It may very well include you. I'll tell you right now that it definitely has included me over the years.

Is an artist's form of neurosis any worse than that of the average human? Not in my opinion. Is it better? No. Is it more interesting? If it produces good work, yes, and sometimes even if it produces bad. Does that excuse artists from confronting, and dealing with, their neuroses? I should hope not.

Look, being a little bit neurotic doesn't make you different from everyone else; it only makes you part of the human family. And, like the majority of us, you'll have to learn to cope with this too. However well or poorly you cope, don't ever fall under the delusion that your quirks isolate you, or in any way make you inferior; to the contrary, they make you like the rest of us. Observe them, know them, work on them, but whatever you do, learn to deal with them. Otherwise, I assure you, they will in time deal with you.

*Love*

Like inspiration, I'm certain it's foolish of me to discuss this, but I feel it's a necessary part of the book.

Few things have been more important to my work than the intense love I feel for certain people. I've gone out of my way to cultivate this in middle age, since when I was younger I excelled at the opposite. Now though love feeds me every day.

When a younger man working on my first novels, my self-absorption, my anger, and my ill-informed opinions tended to drive others away from me. That made for many lonely nights with the typewriter—not necessarily a bad thing for a writer, although there were some nights when I just wanted to knock myself off and get it over with.

Living that way at times seemed unbearable. Oh I had my share of old friends, but our friendships were primarily based on our decadent past, with little bearing on the present or future. I also had my share of lovers, but eventually my uglier traits would drive those women away, and I'd be alone with the typewriter again. In other words, I wasn't really connecting with anyone, and yet so desperately needed to—for myself and my work.

This can either make you crazy, or make you want to change. Well I was already crazy, so I decided to try for change. I went about it in many ways, but the most basic was by admitting my faults and weaknesses, then trying to improve on them. This was a wearying, often exasperating process, where for years what little progress I made hardly seemed to compensate for the pain and humiliation I experienced. But I kept at it, largely because I'm one of those artist types who can never seem to go through life as we are, but instead are always struggling to evolve into something that we aren't yet. Besides, I didn't feel I had any choice.

Fortunately, through all those strange years, my closer friends—both old and new—never gave up on me, and

to them I owe a great debt. These were kind, understanding people who were happy with themselves, their place in life, and wanted to see me get to a similar place. Their gentle patience was a gift I didn't deserve, but they gave it anyway, and the way in which they did made that time of transition, for me, easier to bear.

The years went by. I became a husband and father, and realized that my children needed to be raised by an adult rather than by a self-absorbed boy. So apart from everything else I'd worked on, I began working on that. I'll likely be working on that one for the rest of my life, but only in the way that I want to: part boy, part man; part mischief-maker, part disciplinarian; soother of insecurities, wrangler of the same. No I'm not a typical adult. I look around me and see so many people who have let society convince them that, in order to be an adult, they can no longer be a kid, with a kid's capacity for joy. I'll never accept that. I'd be dead as an artist if I did. Hell I'd be dead as a man.

As I grew older and came to terms with myself, love became easier to win, but more importantly to give. Love of family, love of friends, even warmth for the occasional stranger who only needs a kind word. *This* is the kind of love that feeds me each day.

Then there is romantic love, which is altogether different, but for me just as important.

I've been lucky enough to fall passionately, insanely, connectedly in love a few times in my life, with women who felt the same toward me. It was glorious, wildly erotic, and stimulating beyond words. Each of those loves was precious; not one of them will ever die, since I don't feel that real love ever does, despite the inevitable flaws that those loves may have had.

When I met the woman who would become my wife though, I knew we were fated after the second date. My wife was the only woman I'd met who was willing to endure,

with me, the difficulties that we knew lay ahead. I felt she would give me the love I would need, just as I would give her the same. Fortunately we were right. Does this mean it's been an ideal marriage? I've got news: there is no such thing. But ours has been a very human marriage, with all the usual ups and downs. I have no doubt that more ups and downs, and changes, await us. I am equally sure that, in our way, we will deal with them, since our devotion is eternal, and since neither one of us ever tries to force the other into being something that we are not.

With the other loves that ended, I always felt changed by the time I recovered from the loss: more open to the world, and more grateful. Had I held myself back from those loves, the road would have been calmer but so much less worthwhile. As much pain as I, or the woman, might have gone through on parting, I would do it all again just to feel the ecstasy, the connection, and the certainty that you had known this person before, likely would again, and that it wasn't really ending here.

That kind of love has always inspired me. Of course love of that intensity normally doesn't make for a stable marriage—not that marriage is for everyone—but if you're both compassionate enough, giving enough, and patient enough, it can.

You can try to work well without requited love, like Emily Dickinson or Edgar Degas—not that those two, given their temperaments, had much choice. They worked exceptionally well without ever realizing their amorous dreams; in fact you might say that their frustrations sparked their work. But to me it's much better if you can open yourself to the emotion of love, whether you're straight, gay, sexually driven or sexually indifferent.

Don't worry if no one taught you how to love when you were a child; it is entirely possible to teach yourself. But other people can teach you better. Let them. And if you fail

to sense love the first few times out, and also fail to inspire it, don't worry. That means you're human. Romantic love has always been, and always will be, a complex, maddening, normally painful, often ecstasy-filled journey—a journey without maps, with many wrong turns, and a fair number of collisions. Yes it has its risks, but I've always felt that the bigger the emotional risk, the more rewarding the pay-off. The deeper the wound too when things backfire. But wounds can build character, if you'll let them.

Remain open to all that love can offer, if that suits you. It is one of the greatest gifts of life in this world. It can bring the pot to boil. It can open the floodgates. It can set the fires roaring. It can also destroy you if you let it, but that's a gamble you have to take, and since you're an artist, gambles should be nothing new. Within reason, you should be willing to take them all.

### Summary

That was a long, sometimes messy, rather emotional chapter. But as artists our lives are normally long, often messy, and almost always emotional. I've put all this down because I know it must be discussed, and yet so rarely is. Perhaps that's one reason why I'm writing this: so we can discuss the realities of an artist's life, instead of the myths. Now that we have discussed some of those realities, we have the foundation, and the tone, with which to discuss the rest. Having said that, let's carry on.

# THREE

## *Employment*

Unless you're independently wealthy, you'll have to take a day job, or a night job, to support your work. Take heart, there are worse things—like starving. If you're strong and driven, you can deal with the job for eight or so hours, and still find another four hours each day to do your real work. This is not a bad tradeoff. It might not be an easy way to live, but it's not meant to be. The tougher aspects of this life are what cull the good from the mediocre, and the great from the good. You'll know where you stand as time goes by.

The object is to avoid taking a job you hate. You should also take a job that, if it doesn't complement your passions, should at least leave the art side of your brain undisturbed, so that each day as you work, your talent is working also, subconsciously building up to the hour when you get off work, go home, and do the stuff that counts.

If you're fresh out of college there's no hurry on finding a sedentary job. At least there wasn't for me. I went to Alaska and worked on a fishing boat, losing money and damned near losing my life in the process, but at least I saw the Inland Passage, Glacier Bay, and a gray whale launching into the sky one evening while I sat on the stern drinking coffee.

I continued wandering for years, mostly by motorcycle, working as house painter, construction laborer, farm-hand, mechanic, etc. In this way I satisfied my curiosity about many places—the West Coast, the Deep South, the Great Lakes, eventually Europe—and still managed to write each day.

The best job I ever took during that time, though, was as Director's Assistant at Hill-Stead Museum. An estate-museum in the hills of Connecticut, Hill-Stead houses a collection of works by Monet, Manet, Degas, Whistler, and so forth. I was given a cottage on the grounds and the keys to the museum, where almost at will I could go in and immerse myself in the glories of the collection.

Some days I gave ill-informed tours, other days I mowed the five-acre lawn, other days I felled dead pines. But each day I rose at five-thirty and wrote for three hours before work. The director was very understanding of my drive to write, and tried not to interfere. Given the fire of my temper then, it made things easier for both of us if he didn't. Besides, I busted my butt for that joint, and would have done anything for it, I loved it so much.

That made it forgivable, I suppose, that my girlfriend of the time and I on occasion snuck in late to take private tours. How could we not? The place beckoned to us, we left no trace of our visit, and it was nice to spend time with her beneath the Utamaros and Hiroshiges—her favorites. Besides, Utamaro and Hiroshige would have approved; those guys were artists.

This was a great job. It required physical exertion, it left my brain alone so I could ponder my work, and it made me hunger for greater things. That hunger is important. It will drive you much further than being satisfied will. Too much comfort too early on, and a preoccupation with material acquisition, will dull your senses and drive. You'll wind up becoming a slave to your possessions, and to the

addiction of acquiring more. The only thing you're supposed to be a slave to, at that young age, is your work. Luxury, if it ever fits the artist's way of life, can come later. I warn you though, be leery of that beast if you let it in the door, since once luxury is in, it's very difficult to force it back out.

The best overall job I ever came up with, at least before opening my gallery, was running a lawn-and-tree service. I started this when I was twenty-eight, with an old pickup, a walk-behind mower, and a chain saw. For the first time in my life I was self-employed—the American Dream at its best. I answered to no one, made my own hours, and was free to write each day. The money was tolerable, the work hard, and the rewards of being outdoors great. I did this for eight years, wrote four books in the process, read the Encyclopedia Britannica on my lunch breaks, and still had plenty of time to spend with my family.

Self-employment, if you can swing it, is the best way I know for an artist to control her fate. You can clean houses. You can paint houses. You can work as a carpenter, you can work as a graphics designer, you can work as an illustrator, or a web site designer. You can start a dog-walking service. You can open a coffee cart. You can work as a landscape designer. You can install the landscapes you design. You can work in a tattoo parlor. You can paint custom signs. You can paint bodies. You can even start a lawn service. This is America. You can do anything here, if you have the will and the drive with which to do it.

You can also just take work with a sympathetic employer, in a sane job where the demands aren't too great, and where you can go home each evening and dive into your passions.

The choices are yours, as are the jobs. You might not like any of these jobs a great deal, but you're not supposed to. As I've already said, you're not supposed to get too comfortable yet. Discomfort, and sacrifice, is what prevents

your work from stagnating, and what helps to drive you on. Without that drive to excel your work will go nowhere, and so will you.

*Where to Live*

Again, I have to bring up Europe, since in the end there is no substitute for a month in Florence, a summer in Provence, or Prague in spring.

Europe, for the most part, is a place where art is woven into the fabric of the culture. America, with our particular love for the commercial, is a place where art remains largely outside our culture. This is less true on the coasts than in the Midwest and South, but it remains true overall. It is also a flaw that, at last, is slowly changing. More every year, in small towns and large, in suburbs and urban centers, I see art becoming an accepted aspect of education, a valued part of life—even if only in a minor way. This doesn't mean we're on a par with Italy or France yet, but it does mean we're making progress.

Still we have a long way to go, and many barriers of ignorance to overcome. This is less evident in the big cities than elsewhere, but it remains one of our great stumbling blocks. It is a flaw we must address if we're ever to live up to the vision that the founding fathers laid out for us. (Although Mark Twain felt we'd blown any chance of that long ago.)

As for living in this country, if you live in a small town distant from any major city, it will be much harder for you to break out in the arts than otherwise. Sure the internet and FedEx have made the world smaller, but there's nothing like living in reasonable proximity to a city where the galleries are active, the museums varied, and the art community alive.

In most cities where the population exceeds one million, this is often the case. Living in one of these cities—especially

New York, Chicago or Los Angeles—can be fascinating. In fact I consider it an unparalleled experience. I'm not recommending that you become overly transient though, since in the long run you'll likely do your best work in a studio you're comfortable with, in a place that feels like home. Wherever that place might be, do your best to become acquainted with the bigger cities, and the art communities in them. You'll find that that's an education in itself.

As for suburbs, God help you if you live in one. These are essentially designed as safe places in which to raise children, in a lifestyle that is primarily conformist, reflecting a frame of mind that is often complacent. It is not for obscure reasons that Western suburbs—and by this I mean many European suburbs as well—have often been referred to as *sterile*. How would I know? I live in one.

I decided long ago that I wasn't going to subject my kids to the whims of my artist wanderings. For that reason, I moved us into a rambling bungalow that the developers forgot to destroy when they built our Kansas City suburb. My wife and I could barely afford the joint, but it set my children up in a friendly neighborhood with excellent schools. The suburbs wouldn't teach my kids independence of mind, or the need to question authority, or even the need to on occasion raise hell, but *I* would.

The drawback was, I could never seem to write in that place; suburbs have always deadened me to my work. So I wrote in the gallery. My first gallery was downtown, amid the bums and office workers and traffic and trash. This was a great place to write. The people were fascinating, the neighborhood was good for inline skating, and I was surrounded by old architecture that whispered of older stories. My current gallery, near the Plaza, is a good place to write also. It doesn't have the drama or grit of the first, being in a more prosperous district, but it still beats the suburbs.

In prior years I always lived either in the heart of a city, or deep in the country. Chelsea in New York; rural Connecticut. Ballard in Seattle; a farm on the Olympic Peninsula. Santa Monica in L.A.; a horse ranch near San Luis Obispo. If I had my druthers, I'd still live in places like that. But when the time came to raise a family, we decided on a Kansas City suburb, feeling comfortable here, and at home. I'm not unhappy with that decision, although I sometimes think my more fundamentalist neighbors are. They don't enjoy questioning their values, or beliefs, or *faith*, but with a rebel like me bopping around the neighborhood, they're sometimes compelled to.

All I'm trying to say is you should either live where you're inspired, or work where you're inspired. If that's in the suburbs, fine. The town doesn't matter, the state doesn't matter, the part of the country doesn't matter, so long as you're in tune with the *rest* of the country. Besides, once you start to succeed, you can gain representation in galleries in various parts of the country, who may wind up selling your work all over the freaking country. Then you really will be able to live wherever you want.

How will you gain that representation, and the success that ought to accompany it? Read on. With a lot of hard work on your part, and an equal measure of dedication, I can help you get there.

### Television and the Mass Media

The best thing to do with a television, in my opinion, is to place it on the receiving end of a baseball bat. Very little that's good has ever come from TV, and the longer it's with us—with its multiple channels and opiate influences and passion-draining hypnosis—the worse it gets. Oh you can make sound arguments for public television and documentaries and certain dramas and sitcoms, but the bulk of the programming is corrosive, the kind of corrosion that is

slowly eating at the foundation of our culture, our educational system, and our ability to relate to one another. This anyway is my opinion, based on years of travel, discourse and observation. I don't think it's an inaccurate one.

Own a TV if you must, just exercise restraint in watching it. There's so much else to experience, to touch, to know. Television will keep you from doing this. Your job is to be out experiencing the world, and questioning it, not to become another spiritually numb victim of Madison Avenue.

Example: In 1997 I flew to New York to meet my first literary agent. I hadn't been in the city since 1995, and was happy to be back. I also noticed, with pleasure, that the mood of the place had changed, becoming more sane, and upbeat, than it had been in the seventies and eighties. It was a tolerably civil town again, which both Mayor Giuliani and New Yorkers in general must be given credit for. Whatever the cause, everywhere people tried to be considerate, and often even succeeded. There was a sense of optimism about the town that I don't think New Yorkers had felt since the early sixties. Many of the natives, sensing I was an outlander, asked why I was there. I would tell them, and in every case they congratulated me and wished me luck. I'd never felt more at home in that enormous, swaggering, frenzied metropolis.

I rode the subway across town to my agent's office, and as I did, packed in with the executives and fashion models and Hasidics, I gazed up at the advertising placards. And there, above me, was Madison Avenue's whole mission laid bare. Ads for one of the big networks, they were presenting arguments for why you should watch TV:

*It's a beautiful day. What are you doing outside?*
*Scientists claim we only use 10% of our brain cells. That's way too much.*
*Hobbies, Schmobbies.*
*Eight hours a day, that's all we ask.*

*Don't worry, you've got billions of brain cells.*

And so on.

I could almost see the group of miserable souls who, together in some soulless board room, composed these passages. It was *so* New York.

So if you're an avid watcher of television, just be aware of the networks' ultimate values. It doesn't matter which network posted those values; in my opinion they're all interchangeable.

Newspapers and magazines are different, yet similar. We are daily bombarded with information from a growing number of well intentioned, but basically superfluous, periodicals and websites. If you try to subscribe to too many of these, you'll wind up being informed on all kinds of issues that you can do nothing about, have no influence over, or any involvement in.

Your job isn't to become a master of current events. Your job is to live outside the world at the same time that you live in it. There's nothing wrong with being well informed— I skim through the paper each morning, and listen to NPR each day—but I don't advise that you get sucked into the vortex of global information. It's all too vast to keep up with, and often the way it's presented is too absurd to bother over.

A conversation with a new friend, a debate with an old one, a bout of volunteerism, a long jog, a brief swim, an engrossing book, a bad play, or just a good night's work. You'll get far more out of these things, and others like them, than you ever will from an evening of news magazines and canned laughter.

### The Simple Art of Reading

As most of you know by now, your education truly begins after college, not during. Ideally college opens your mind, making it receptive to new ideas, new concepts, worlds within worlds. When college is over, you'll hope-

fully find yourself hungering for more knowledge. A great deal of this you'll acquire firsthand, through experience. The rest you'll acquire through books.

I cannot emphasize enough the inspiration that can come from a well-balanced habit of reading. This will broaden your knowledge of the world, history, and prominent artists in a way that nothing else can, which will in turn affect your work, which will in turn affect you. It will also assure you of how art is woven throughout all cultures, all peoples, all historical events. Sometimes art is influenced by those events, other times it presages them. By studying the history of art, and the figures immersed in it, you'll learn about the natures, drives and adversities of artists from other eras and cultures. By studying other subjects, whichever you may choose, you'll simply learn.

I'm not necessarily recommending scholarly reading; I'm not a scholar myself, and most artists I know aren't either. Sure, I enjoy the occasional philosophical treatise, but even more I enjoy a fascinating biography. When well-written, a biography can read like a great novel. What makes this more relevant to you, if the book's about an artist you admire, is that by the time you finish it, you'll realize how much you have in common with that artist: the struggles, the despair, the successes. The book will also fill in educational gaps relating to the humanities, geography, and the commonness of the human experience.

Books I've recently finished are biographies on Orson Welles, Simone de Beauvoir, Degas, Truman, Jim Morrison, Winston Churchill, Jackson Pollock and Sylvia Plath. Each of these books not only discusses the life of the person concerned, but naturally the lives of related figures and events in some depth. This in turn leads to other subjects, and a general broadening of knowledge. Then there are the novels I read, and reread, but I'll not get into those here, since that's got nothing to do with this.

Beyond books there are the usual art magazines and periodicals that will relate to what you do. Some of these will speak relevantly to your interests and medium, others will serve very little purpose at all. The right periodical though, especially if it's well-written, will keep you abreast of new installations, exhibits, debates, petty squabbles and emerging artists. Some of this is worthwhile, a great deal of it is not. You'll know for yourself what you want to bother over. But as you follow events and trends, try to keep an open mind, try to avoid preconceived judgments, and, most importantly, keep true to your own vision.

Combined with broad experience, travel and devotion to your work, the habit of reading regularly will take you places that nothing else can, and open inner doors like nothing else will. But then I would say that, wouldn't I? I'm a writer.

### Graduate School?

Before we go on to some of the more practical topics, I suppose it is imperative that I discuss graduate school. Whether you intend to go or not, I feel it's important that you grasp the fundamentals of this option.

An MFA of course is not for everybody, either financially or inspirationally. For those of you who are confident enough in your talent, and connections, it may well be a waste of time. For those of you who don't feel this way, it would give you three more years to develop your work, as well as those connections that the art world so much revolves around. Even if your instincts do guide you toward graduate work, there's not necessarily any hurry in signing up. Take a year off to mature if you like. Move to some other part of the country, or some other part of the world. See how this affects you. Then when you're ready, make your return to academia with renewed vigor.

Before you choose your school, determine just why it is you're going back. Is it to grow artistically, or are you merely going back to kill time and chase boys, or girls? Is it to get your MFA so that you can go on and teach? Do you even want to teach, and if so are you suited to it? If you do wind up teaching, will the academic life impede your artistic growth, or do you feel you'll thrive within it, despite its politics, responsibilities and obligations? All of these can be good reasons for going back; I'm just asking you to decide which, if any of them, apply to you.

If you do decide to return, you may want to consider selecting a school that's new to you, in a part of the country that is new as well. This will broaden your experience, and also broaden the credibility of your resume.

Assuming you gain acceptance at the university of your choice, what can you expect? Greater freedom, for one thing: freedom to choose the courses you want, and especially to spend a lot of time in the studio. Many of your required courses are behind you. Now you can focus on the things that apply more directly to your vision and goals. Also, other artists in the program will, like you, now be at a higher level in their work. You'll find this both stimulating and challenging—and on occasion frustrating, especially if you feel they've outdistanced you. Don't think in those terms; you should run by your own clock, not anyone else's. Finally, you'll get the chance to meet established artists who are on the visiting artist program. You'll get to talk with them, benefit from their experience, and perhaps pick up a contact or two. This alone can be a very good reason for making the return.

Apart from all this, you'll also get to spend time with professors who have been in the game for decades. They'll take you more seriously now than when you were an undergrad. Bull sessions over wine or coffee will give you insight, encouragement, and on occasion discouragement,

depending on the nature of the professor, and her level of optimism/skepticism. Many of those professors will tell you about their work, their experiences, goals they met, and goals they never achieved.

Some of them will be outstanding artists at the same time that they're outstanding teachers. Some will be just average artists but extraordinary teachers. Others will be both horrible artists and horrible teachers, burned-out on everything—art, teaching, students, and life itself.

Try to gravitate toward professors who inspire you, who are inspired themselves, and who have a realistic view of the world you'll soon enter; their wisdom is critical.

If you choose to enter that world as an instructor, just make sure you're as devoted to teaching as you are to your work. If you can't be both, then make sure you're devoted to teaching. Maybe *that* will be your art. If so, I can think of few contributions more worthy.

### Heritage

Remember, this is your country. You're a citizen of the world, sure, and are to be lauded for trying to attain a world view, but this is the country that formed you, and gave you the opportunity to pursue your calling. As Americans we've accomplished a lot of good for the world. We've also rendered plenty that is bad. We're by turns a mediocre, whining, perpetually dissatisfied people. But we can also be brilliant, faultlessly generous, and we do remain, despite the many flaws in our system, one of the world's great republics.

Try not to take that for granted. Don't discount the people who came before you, who sacrificed for the right to vote, the right to an education, the right to a life of dignity. Don't discount either all those soldiers who died on our own soil, or on faraway beaches, or in distant, festering jungles—some for the preservation of democracy, some for

the paltriest of capitalist motives. Especially don't discount the ones who died in that murderous war that ended just half a century ago, that took fifty-five million lives with it, and that brought us the world, for better or worse, as we know it now. They died so that you and I could have the *privilege* of drinking beer on Friday nights, and complaining about what a bitch it is to be an artist. Don't complain too much. Count your blessings that you have the opportunity to pursue your dreams, and to overcome your hardships; the bulk of the world has not.

Grapple with those hardships—you're meant to. Then transcribe the experience into brilliant work—you can.

# FOUR

### *How Will You Know When You're Ready to Show Publicly?*

By this I don't necessarily mean showing in a gallery, but just in public venues. Showing in galleries will come later. But before most of those galleries will even look at your work, they'll want to know whether you've exhibited publicly. So, how will you know when you're ready?

If you've done your homework, if you've paid a good portion of your never-ending dues, and if you're more or less pleased with your work, then you will know. You'll also know it if you trust your inner voice, and your critics. Friends, by the way, tend to make lousy critics. For criticism, rely on people who owe you no form of loyalty. Rely on people with a good eye and appropriate sophistication and a feel for what you're trying to achieve. This means that if your work is avant-garde, then a devotee of Maxfield Parrish would likely be a poor choice of critic. Whoever your critics are, consult them, and the harsher aspects of your inner voice, before you commit to exhibiting publicly. After you've consulted all of these sources, then I suspect you will be ready.

You may still be in art school when this occurs, or you may be several years out. However the timing works, you can be sure of one thing: there is no way that you'll be as well prepared for your first show as you will be for

your fifth. But diving in and undertaking that first show is how you'll learn to prepare for the later, and more important, ones.

Example: In my case, how did I know when I was ready to begin approaching agents and publishers? Because after having written for seventeen years, I had become confident in my work, and my critics felt the same. Once I had achieved that confidence, I went after the New York agents, since I knew publication would be impossible without one; four offered me representation. I selected the one that I was most comfortable with. As you know by now, he didn't work out, but landing him did confirm to me that I was on the right path, and that my work had power.

What if I had approached him three years earlier? I'm quite certain that he, and all the others, would have turned me down. Why? Because my work wasn't mature enough yet. Similarly, I advise that you don't push too hard for public exhibition until you know you are ready, however you arrive at that conclusion.

Painting and sculpting are a little like writing books: you never really finish one, you just reach a stopping point and realize you've done your best. You reach a point where the work cannot grow any further, and often resists any attempts to make it do so. At this time your instincts should be telling you that if you persist, you may disrupt the initial spontaneity of the work and create an imbalance. You can polish it, you can refine it, but further raw creation may well be a mistake. Or it might also be, like my early books, that the piece simply isn't worth reworking; that you learned from it all you could, and it's time to move on.

Whatever the case, you must know when to stop, when to let a work go, and how to determine when it is "finished." Your instincts should tell you this, even more than your critics.

All that aside, let's assume that you're ready. How do you begin the actual, step-by-step process of putting your career together, gaining a following, and achieving the goals you've set for yourself? Well that's a tough, complex question to which there is no single answer. I can, however, provide you with some methods and approaches that will help you find answers in this strange, unpredictable, lovable business. I'm not claiming that my methods are the only ones. I *am* claiming though that I've utilized them to great success, for both my gallery and artists.

I'm going to begin with some fairly obvious, highly practical observations. I have to, since it always amazes me how you freaking artists so often fail to employ the obvious. I realize that's your bent, but get over it a little. I had to.

So then, on to the practical.

### Photographing Your Work

I'm not a technical writer, and this isn't a technical book, so I'm not going to get into the intricacies of photography in that sense. Besides, there are many books that already do this, and do it much better than I ever could. Hunt down your book of choice, buy it, and teach yourself to deal with this necessary chore. You can save thousands of dollars by doing so. But for basic advice on the issue of photographing your work, read on.

If you can afford a professional photographer, hire one, at least until you know how to take good photos yourself. This doesn't mean you should hire the most expensive photographer, with the most elaborate studio, in town. Instead, try to find a pro who shoots out of her home. These shooters you can usually find in the phone book, or through photography societies, or custom developing labs. They're far cheaper than more established photographers, their turnaround time is usually quicker, and the work is more than adequate. I rely on several of these types of photographers.

At the time of this writing, I pay twenty dollars for a well-shot slide of a painting, and forty for a 4 x 5 transparency. For a slide of a sculpture I pay sixty dollars—sculpture being more expensive because it requires more setting up. If digital photography is required, the above images can simply be scanned, then transferred to disc for a minor fee. Regardless of where you live, you should be able to pay roughly the same prices that I do. Don't go in for ultra-expensive, ultra sleek photography yet. That can come later. For now, merely competent photography will do.

If you can't afford to hire a photographer, don't worry. With a good camera, you can learn to shoot your own work well enough.

One of my artists, a fine abstractionist who works in gouache, shoots her paintings outdoors, on slightly overcast days, against the white wall of her garage. The lighting is perfect, she always crops in close to eliminate the wall, and the galleries all think the photos were shot in some studio. If the day is sunny, she simply shoots the piece in mild shade, using a transportable background. If the painting she's shooting is exceptionally dark, she'll sometimes utilize direct sunlight, but not often, since this tends to wash out color and often leads to problems with glare. This artist uses a 35 mm Pentax. She bought it used for little money, and it shoots beautifully.

This unorthodox method is actually quite acceptable, and can produce more than adequate results—a great advantage when you're just starting out, and are broke. Eventually though, it will be best if you can set up a corner in your house or apartment where, with the proper lights, backdrop and camera, you'll be able to shoot your work with a fair degree of professionalism.

With cameras, it's better to stay away from those with auto focus. I recommend standard non-autofocus 35 mm single lens reflex models, which are common. I also recommend,

in the following order, Nikon, Canon, Olympus, Pentax, Minolta. There's no need to buy a new camera. In fact the older ones, with metal  housings, tend to produce better shots than many of the newer ones. They are also more reliable, and can be easily repaired.

When you shoot, you rarely should use a flash. Like direct sunlight, it will tend to wash out color. As I've already indicated, outdoor light, without a flash, is among the best light sources available. But if you can afford studio lights to shoot indoors, so much the better. Either way, if a background must show, it must normally be neutral. Depending on the work, the background can be black, gray, white, or any variation thereof. Don't get too arty with the background, or even with the shot. Your work is the art. Let that be the primary focus of the photo.

We always shoot both slides and prints. Many galleries say they view only slides. This is nonsense. Most art dealers I know prefer 4 x 6 prints for ease of handling and viewing. They like slides as well, but how many people keep a projector, or viewer, ready and waiting?

Of course you do need slides. There are many galleries that will only look at slides; you can't print a proper ad without a slide or transparency; and you can't enter a juried show without slides. But if you have both slides and prints, you can satisfy most needs.

Through the course of all this, bear in mind that it will take a fair amount of practice before you'll be confident of your camera, lighting techniques, and film choices. In the beginning, you'll inevitably waste several rolls of film in learning these fundamentals. Once learned though, they'll serve you well for years to come.

Digital cameras? Virtually everything I've discussed involving traditional cameras applies to digital cameras as well—that is if you can afford to buy one. Of course they're wonderful for updating websites, e-mailing images, desk-

top publishing, etc. They also save considerable money in developing costs, and over time can pay for themselves. I address this at greater length in Chapter Eight.

Finally, do you necessarily need to photograph every work that you execute? No. Shoot the ones you're happiest with, and that you feel best represent you. Once you become famous, you can worry about documenting the total extent of your output.

### Resumes

It is time we discuss the necessity of the resume, and what to list on it. If you feel you haven't yet accomplished enough to make for an impressive resume, then writing a biography may be better suited to your career at this stage (I cover bios in the next section.) But whether you feel you're ready to write a resume or not, I'd like for you to read through *this* section first. It will likely give you several ideas about how to describe your work, and may also teach you a lesson or two about promotion.

By the way, please do not look down on the word "promotion." Picasso was a master promoter. So was Diego Rivera. So was Andy Warhol (although I suspect that getting shot was outside the realm of his plans). It's a part of the business. It can be a very distasteful part of the business if handled in the Barnum and Bailey sense, or it can be a very sophisticated aspect if handled with integrity and intelligence. I personally see it as an essential means of informing my clients about the worth of my artists, which in turn assists me in helping my artists make a living. Needless to say, I'm pretty keen on both points.

As for resumes, I've printed below what a typical one looks like—this for a sculptor who works in stainless steel. Some of the things I've listed are substantial achievements, some are not. I list them all regardless, since as a whole they often seem more impressive than they do individually.

Use this format as a guide for your own resume if you like, or formulate your own. So long as the thing reads well, it should do just fine.

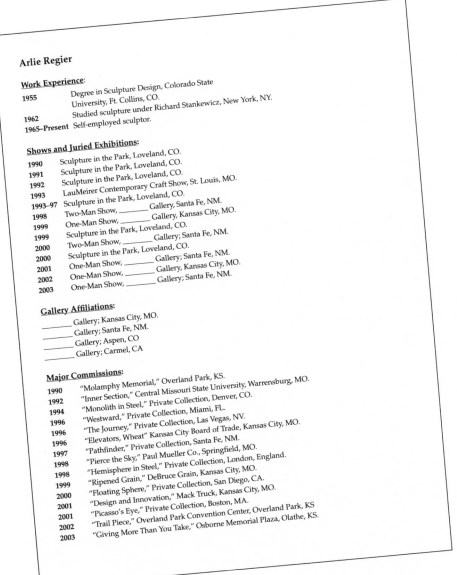

**Arlie Regier**

**Work Experience**:

1955    Degree in Sculpture Design, Colorado State University, Ft. Collins, CO.

1962    Studied sculpture under Richard Stankewicz, New York, NY.

1965–Present Self-employed sculptor.

**Shows and Juried Exhibitions**:

1990    Sculpture in the Park, Loveland, CO.
1991    Sculpture in the Park, Loveland, CO.
1992    Sculpture in the Park, Loveland, CO.
1993    LauMeirer Contemporary Craft Show, St. Louis, MO.
1993–97 Sculpture in the Park, Loveland, CO.
1998    Two-Man Show, _____ Gallery, Santa Fe, NM.
1999    One-Man Show, _____ Gallery, Kansas City, MO.
1999    Sculpture in the Park, Loveland, CO.
2000    Two-Man Show, _____ Gallery; Santa Fe, NM.
2000    Sculpture in the Park, Loveland, CO.
2001    One-Man Show, _____ Gallery; Santa Fe, NM.
2002    One-Man Show, _____ Gallery, Kansas City, MO.
2003    One-Man Show, _____ Gallery; Santa Fe, NM.

**Gallery Affiliations**:

_____ Gallery; Kansas City, MO.
_____ Gallery; Santa Fe, NM.
_____ Gallery; Aspen, CO
_____ Gallery; Carmel, CA

**Major Commissions**:

1990    "Molamphy Memorial," Overland Park, KS.
1992    "Inner Section," Central Missouri State University, Warrensburg, MO.
1994    "Monolith in Steel," Private Collection, Denver, CO.
1996    "Westward," Private Collection, Miami, FL.
1996    "The Journey," Private Collection, Las Vegas, NV.
1996    "Elevators, Wheat" Kansas City Board of Trade, Kansas City, MO.
1997    "Pathfinder," Private Collection, Santa Fe, NM.
1998    "Pierce the Sky," Paul Mueller Co., Springfield, MO.
1998    "Hemisphere in Steel," Private Collection, London, England.
1999    "Ripened Grain," DeBruce Grain, Kansas City, MO.
2000    "Floating Sphere," Private Collection, San Diego, CA.
2001    "Design and Innovation," Mack Truck, Kansas City, MO.
2001    "Picasso's Eye," Private Collection, Boston, MA.
2002    "Trail Piece," Overland Park Convention Center, Overland Park, KS
2003    "Giving More Than You Take," Osborne Memorial Plaza, Olathe, KS.

*Figure 1. Sample resume of Arlie Regier*

This resume fits onto one page, and quickly informs the reader of the sculptor's accomplishments. Do I mention that he very nearly gave away his first commission, "Mol-amphy Memorial," as well as his second, "Inner Section?" (Some business people took advantage of him.) No. Nor do I ever mention his sacrifices, or how tough the road was, or how numerous the setbacks. The only thing I indicate is how successful he is now. Besides, once I took on his career, his prices rose, his belief in himself shot up, his designs became bolder, and now he's one of my most sought-after artists. Now he and I *can* talk about his starvation years, but only because success has been achieved. If we hadn't achieved it yet, there's no way I would discuss it.

In filling out your resume, you'll likely have to use a similar tactic of making yourself seem more successful than you feel you are. There is nothing wrong with this, so please feel no guilt.

Example: When the Beatles, still largely unknown in 1962, were preparing to leave Liverpool for an engagement in Germany, their manager printed up posters promoting a concert they were to give prior to their "European Tour." That tour was a long-term gig at a cheap club in down-town Hamburg, where they slept in a dank back room, and played eight hours a night for pennies—or *pfennigs*, if you prefer. Still, did this type of promotion detract from the uniqueness of their music? To the contrary, it helped their style to become better known. Within two years they were on the Ed Sullivan Show, and the world of music, if not the world of youth, was changed forever.

As we've already discussed, if your work has true sub-stance, and you *know* it has substance, these mild exaggera-tions do no one any harm. It's the work that counts; the promotion of it merely helps you to take it where you need to go. So fill out the resume, exaggerating if you must—but *never* lying. As the years go by you'll achieve things of

greater significance, making moot the need to exaggerate. Of course it would be great if you never had to exaggerate at all, but rarely will you meet a successful artist who didn't have to do the same when they were younger. Very rarely.

### Artist's Biographies

If you haven't yet accomplished enough to make for an impressive resume, you can simply write a bio, which can often be a mild combination of the two. Below I've listed a typical bio, this for a young woman who recently joined my gallery. Due to her youth, her accomplishments don't yet rank with those of my other artists, but I know in time they will; her work has a sophistication that goes beyond her age. But for now she needs a bio that simply reflects her skill, and uniqueness, as a painter. Accomplishments of greater significance will come later.

# Kim Casebeer

Kim Casebeer has been working as a professional artist since 1995. While her primary subject is the Flint Hills, her work focuses not so much on a particular place but on dramatic use of color and light. This has brought her to be placed in collections in San Francisco and Aspen, as well as regionally. She is especially passionate about interpreting skies at various times of day and year.

Kim received a Bachelor of Fine Arts Degree from Kansas State University, and is a member of the Mid-America Pastel Society, the Pastel Society of the Southwest, and the Pastel Society of America in New York. In 2003 she juried into the Pastel Society of America's 30th Annual Exhibition, held in Manhattan.

Kim has exhibited in several juried competitions such as Art in the Woods in Overland Park, and the Mulvane Art Museum's

Triennial in Topeka. She has also exhibited in national competitions sponsored by each of the pastel societies listed above.

Kim has been featured in numerous one-person shows and exhibits at _____ Gallery in Kansas City, and _____ Gallery in Manhattan. Her work is in several private, corporate and museum collections.

If you can glean any ideas of how to write your bio from this, feel free to do so. And please notice that this woman has made a point of joining the various societies that reflect her medium. This may not appeal to everyone, but if you can gain membership to an oil-painting, or bronze-sculpting, or glass-blowing society, it can only help your credibility, assuming that the society is credible. Believe me, if you ultimately want to make a living from your work, this can only help. But for all you more rebellious artists for whom there is yet no society—well, you probably wouldn't want to join one anyway. So, form your own.

### Artist's Statements

If well-written, an artist's statement will take the place of a resume while you're building up that resume. Keep the statement brief, keep it to one page, and don't over-explain the subtleties of your work. Either your work speaks for itself, or it doesn't. Too much explanation doesn't reflect confidence, rather the opposite. Let the work speak. Be sure also to put in your educational background, and any relevant experience, training or shows that you have behind you. Factual biographical information is always more important than fluff—although if you lack the former, the latter will do for now.

Your philosophies, inspirations, ideas and vision—put these things in if you like, just be concise. The people viewing your work, for the most part, won't pay much attention

anyway. It's not that they're indifferent, it's just that we live in an age where *everyone* is bombarded with far too much information each day. There's not much point in adding to that, when your work is supposed to provide relief, or shock, or contrast to those very elements of our lives. Let the work speak. The better you become at this, the less your artist's statements will matter.

For now? Sure, write it. Work out those ideas on paper. It's a good exercise, as I find most writing is.

## Portfolios and Presentation Folders

If you're like most artists, you'd much rather be creating new work than assembling a portfolio. Yes they're a pain to deal with; I've never yet met an artist who enjoys assembling them. *I* don't enjoy assembling them. But of course they're essential. If you look on the portfolio as a work of art itself, utilizing a direct presentation that is visually stunning, it won't seem such a bore. Spend the necessary money on it, and on the photography, to make it look good. The money will be returned by means of sales.

For those of you who have absolutely no interest in selling your work, create the portfolio in whatever fashion you wish. Make it sleek, make it ragged, make it out of duct tape if you like, so long as the finished product adequately represents your work, your passion and ideas. If the notion of making money from your art doesn't jive with the way you create, then let the portfolio suggest, or even shout, this as well.

Regarding portfolios, I recommend the following:

1) Portfolio Size:     17" x 20"
2) Size of Photos:    8" x 10s" or 5" x 7s" (no smaller)
3) Other elements:   Resume or Bio, an Artist's Statement, and Press Clippings.

Lay out the photos two-to-a-page, or four-to-a-page, depending on the size you choose. My personal preference is two 8" x 10s" per page, because they give the viewer the best visual impression of your work—and that first impression is the most important one you'll make. Repeat: THE FIRST VISUAL IMPRESSION YOU MAKE ON A GALLERY DIRECTOR, OR COLLECTOR, IS THE MOST IMPORTANT ONE YOU WILL MAKE. Please never forget this.

After you've laid out the photos, put the resume and artist's statement at the end. I never put these items at the beginning of a portfolio, because I want the viewer to be impressed with the work itself first. Once that impression has been made, then they'll be willing to read about the artist. Needless to say, when I lay out a portfolio for an artist, I always place the most stunning images on the first pages, with the weaker ones following, then finishing again with the stronger works. If it's *all* strong, so much the better.

In addition to the photos in the portfolio, you'll need several sheafs of duplicated slides (not original slides), with ten to twenty slides per sheaf. You carry these so that you can leave them with interested parties. If you want the slides returned, be sure to hand them out in a stamped, self-addressed envelope. Dupes are normally cheap to make, if you're selective in your choice of developing company. As with all other expenses, shop around and find out who does the best work for the most reasonable price. You want quality duplications that read as well as the original slide, but you don't need to get stiffed in the process of ordering them.

Just as importantly, anytime you show your portfolio, try to have a small original with you, since the work itself will always read better than a photograph, no matter how well the latter is shot. If a gallery director, or collector, is already looking at photographs and liking what they're

seeing, you can reinforce this by casually showing them the small jewel that you happen to have at hand. Note use of the word "casual." Contrary to general misconceptions, the art business does not function at its best in a mode of pretension and pressure; rather it is always at its best when everyone is relaxed: the artist, the dealer, and especially the collector. Relaxation leads to trust, trust leads to sales.

If you can't afford a portfolio, or don't like the idea of lugging one around, then just purchase a presentation folder. You can find these in any office supply store. They're the size of a notebook, are filled with transparent sleeves, and can make a very impressive visual statement—although normally not as impressive as that of a portfolio. One advantage, however, is that you can make up several presentation folders, which gives you the means to loan one to a good prospect if the opportunity arises. This is something that is not so easily done with a portfolio.

Along with the photos in your portfolio or folder, and the resume, you'll also need to include any press clippings you might have garnered over the years, and a select list of clients. What? You don't have those yet? Don't worry. I'll go over the getting of press, as well as how to acquire that coveted list of clients.

### Pricing Your Work

How do you go about establishing fair prices for the works you create—meaning *fair* to you as well as to potential collectors? Easy. Get a dart board, tape a range of prices to it, toss six darts at the sucker, and see where they land. The middle figure wins.

You don't like that? Then try this: go to a series of galleries, find works by established artists that are in some way similar to yours, then set prices that you're comfortable with in comparison. If the established artist is in the range of, say, $15,000 per painting, this is likely not a realistic comparison. If they're

in the range of $700 to $4,000 per painting, depending on size, that will likely be more suitable. Even then, it would not be practical for you to charge the same prices. The artist whose work you're viewing has probably been at it a long time, paid heavily in her dues, and is now reaping her rewards. If you're in the beginning stages of your career, it's doubtful that you're at her level yet.

The same rules apply to sculptors, ceramists, etc.

Of course I can't tell you what prices to set, but I can say that initially they should be moderate. It's unlikely that you'll make a killing right out, and it's generally unwise to expect to. I advise that you concentrate on placing as many works with as many people as possible (Yes, I'll explain how to do this), which in the beginning is normally achieved through moderate pricing. These clients can then be listed on your resume as collectors, which will lend you and your work greater credibility as your career expands, and as you later approach galleries. In the beginning, you want to make it easy for those collectors to buy your work. In fact it should always be easy, it's just that later on it should also be more expensive—in fairness to you, and all you've sacrificed.

In relation to this, I'm often asked by novice browsers why paintings and sculptures are always so "expensive." In my gallery, prices currently range from $800 to $10,000 for in-house pieces. (Commissioned work is a different matter, which I address in Chapter Eight.) These are hardly expensive prices by New York standards, but they *are* expensive to the vast majority of the populace, regardless of where they live. Of course the question is a reasonable one, so I always try to give a reasonable answer.

Typically I explain that my artists have been working in their disciplines for anywhere from twenty to forty years. They've established, through decades of struggle, techniques that are unique to them—meaning that their work is

uncommon. They have now reached the point where they're due proper compensation for all the privation they've been through, and, in most cases, that their families have been through as well. To charge any less would be a disservice to the artist. I carefully explain all this, then finish by asking the questioner that if they'd been down such a long, exhausting, risk-imperiled road, what would they charge for the work? Invariably the answer is, "More."

I say, "Very good," then proceed to close a deal.

## Where to Show

If you're not in a thriving gallery yet, then how on earth do you get your work before the public? Easy. In fact here's a list of possibilities.

CORPORATE OFFICES: Every corporation has a group of art lovers within, and potential art lovers throughout. No matter where you live, some sizable corporation exists nearby. Contact the person responsible for displaying art there. Sometimes this is a curator, sometimes an executive, sometimes an office manager. Of course most corporations have never done this at all. Great: this is your chance to introduce them to something new, and inspiring.

You can install your work in the executive offices, in a common hallway, or in the lobby. You must price and title each piece, and put out a resume or bio that is easily found. Make sure the area you install in is secure, and if possible have the corporation insure the pieces. Your contact information must be on the bios. Make it easy for people to reach you, and make buying a pleasure for them. Be prepared to come down 10% on the price, 15% if you have to, but no more. Coming down too far demeans the work, and you.

After installing the pieces, organize an opening if possible. Invite your friends, their parents, their grandparents, and any rich folks that you can toss through the door. Make yourself accessible at the opening. Don't be aloof or drunk.

Be nervous if you must—that's a human and perfectly endearing quality. More importantly, be willing to talk. You don't need to only talk about your work, although if you want to sell, conversation will eventually have to gravitate in that direction. Still, don't make discussion of your work the sole focus of the evening. Relax. Have a glass of wine. Have fun. Fun, like trust, leads to sales. Believe me.

LIBRARIES: These can sometimes be bureaucratic, rather dull places in which to show, but they do constitute a show, and all worthwhile shows are important in filling out your resume. As with any exhibit, try to organize a formal opening.

RESTAURANTS: Any well-run, well-patronized, well-lighted restaurant will do. Talk to the owner. Chances are, if they're not currently exhibiting any art, they'll be thrilled to have new work there—assuming they respond to it well. If they don't respond to it, talk them into it anyway. You're not selling to the freaking owner, who may have no appreciation of art whatever, but to his customers. They're the ones you want to reach.

Naturally you want to choose a restaurant of some affluence. If you choose a coffeehouse where everyone is hip and no one can afford to buy, you'll likely get a good response, but few, if any, sales. If you don't want to sell, this is fine. If you do, it's not.

CITY OFFICES: Many city halls and administrative buildings are open to hanging works of art. You may not get a single sale, but at least it's a venue, and, again, you'll need venues to fill out your resume. If you're a painter but are not allowed to hang work on the walls, use easels. If you can't afford to buy easels, design and build some. Lumber is cheap, and anyway your designs will likely be more interesting than those of the store-bought variety.

OTHER VENUES: Churches, university galleries, upscale bookstores, upscale hair salons, hotels, architecture firms,

interior design firms, law firms, convention centers, airports, private clubs, or a showing in some socialite's home. You don't know any influential socialites? Tap someone who does. This may lead to introductions, which may lead to interest, which may lead to sales.

COOPERATIVE GALLERIES: You could always try to start one of these if you like. They are essential to the art world, and for a century now have contributed to America's understanding of, and coming to terms with, art. They're fascinating, they can be a great deal of fun, and they almost always lose money.

If you do help start one of these, let me give you one piece of advice: *make sure the director has sound business as well as aesthetic sense.* You artists, with few exceptions, tend to have terrible business sense, and are often lacking in the talents that it takes to run a gallery. Your talent lies in the creation of art, not in the promoting and selling of it. That takes a different frame of mind, with different talents. You can help run the gallery, you can help hang the shows, you can mop the bloody floor if you like, but assign the bulk of the business decisions to someone who is adept at handling them. In fact it's best if this is more than one person, since it normally takes a qualified team, with cooperative attitudes, to put together winning strategies.

How do you go about setting up one of these galleries? I'm afraid you'll have to ask that of someone who has been involved in a cooperative, or who is currently running one, since I never have. But if you want ideas on the subject of starting a gallery in general, you'll get many of them from Chapter Six, where I discuss the history of my gallery, its ups and downs, my near-bankruptcy, my damned near going mad, my eventual success.

As for cooperative galleries, if a group of you start one, I first of all salute you: it's a noble undertaking. It's also a very brave one, with more than its share of difficulties:

organizing shows, attempting to interest the press in the shows, attempting to interest collectors, paying rent, paying utilities, dealing with marketing, dealing with staffing, and trying to ensure that everyone gets along during the course of all this. It is, I assure you, no easy task—not if you're to do it well.

By the time that gallery closes, provided it does, it's quite possible that you'll be tired of the art scene, and that the group who started the cooperative will no longer be speaking. Everyone will likely be blaming someone else for what they perceived was done poorly, or what they feel went wrong. That's all right. Get it out of your system, admit your trespasses, forgive the trespasses of others, then forget it and go on.

Opening a cooperative gallery, and later watching it close, is not a loss. The experience can teach you valuable lessons about the art business, as well as about your own art and the person creating it. Your growth can be profound as a result, but only if you choose to learn from the experience. Bitterness can also be the result. In fact bitterness can be the result of most endeavors, if you allow it to be. I don't advise that you allow this; in the long run that leads nowhere but down a series of self-defeating dead-ends.

If the gallery doesn't fold, and everyone gets along swimmingly, and you even turn a profit, please tell me how you did this. I've yet to hear of a single cooperative that has.

SUMMARY: In dealing with any of the above venues, try to be businesslike, try to be helpful, and try to make it a pleasure for others to view your work. Equally important, just enjoy the fact that your work is on public display. That is without doubt a major step in the beginning of your career.

### Press

Obtaining press is really not as difficult as you might think. Most reporters are part artist. They sympathize with

the arts, and with the struggle of the artist. They also tend to respect what artists do. Thanks to their interest, my artists and I have appeared in roughly eighty different articles, and have been interviewed for television dozens of times. Did this happen by coincidence? I wish it had; that would have saved me hundreds of hours writing press releases and making phone calls.

Anytime you organize a showing, or better yet, an installation, it is essential that you try to get a reporter to cover it. Notice I said "reporter" and not "critic." Chances are the critic is overworked, without a staff, and is focusing primarily on big-name artists who are showing at a museum or established gallery. Besides, you're really not seeking criticism yet, just exposure.

In order to get press, all you need is a reporter who is able to write about cultural events. It will be a nice break for them, as well as a diversion from the murders, car wrecks and political scandals that they otherwise cover. If there is more than one paper in your town, then of course you want to involve a reporter from each.

How do you convince a reporter to cover something of this nature? By means of a simple press release, *with good photography enclosed*, since a release without photographs will get no one's attention. You can make the release formal and impersonal, or informal and personal. I tend to utilize the latter approach, since I find it brings the best results.

On page 70 is a sample release I sent out to area papers and television stations, encouraging them to cover one of our projects (Figure 2). Please note that I open the letter with the essential facts, since reporters have time for nothing else.

Were reporters immediately dispatched to cover the event? No. In fact I had to call each assignment editor to ensure that they were going to do the story. Certain editors never even received the release, and I had to send it a

Name of Newspaper
Name of Reporter or Assignment Editor
Street Address
City, State  Zip

Dear _____:

Starting Monday, 10/14, we will begin installing a 37' sculpture in blown glass at the Overland Park Convention Center. This piece, by Vernon Brejcha, hangs inside a 75' glass tower, and is only one of 61 works that we will install this month. Installation begins at 9:00 a.m.

I've been working as art consultant for the convention center for two years, assembling a collection of works by 52 regional artists. Some of these pieces are huge, others are moderate; I feel that all are stunning.

I've listed the installation schedule in case you want to send a photographer. Please note that the glass sculpture is the signature piece for the facility.

There are also large freestanding sculptures, wall-mounted sculptures, numerous paintings, and works on pedestals. The entire installation process will take about two weeks, and I assure you will be dramatic. You can interview the artists, and public, in getting their response to the project.

From the beginning, I've insisted on using artists who had ties to this region. I have always believed, and now have proven, that certain regional artists have the sophistication to rank nationally. We've also utilized artists who were virtually unknown, but who had earned this opportunity. I believe the result is a great success.

Please let me know if you have any questions regarding this story.

Sincerely,

Paul Dorrell
Director

*Figure 2. Sample letter to media outlets*

second time. But by politely persisting, I eventually got all of the major papers to cover the event, along with three out of the four TV stations, as well as the local National Public Radio affiliate. That resulted in good coverage, but partly because I followed up with each editor.

You do not have to be involved in an event as large as this to get coverage. Any public event will do, and quite often corporate events as well. Never assume that reporters won't cover your event; just send them the information and let them make that decision. You can also fax them, if you feel a fax will adequately cover the subject at hand.

RECAP ON SENDING OUT A PRESS RELEASE:

1) Two weeks before the event, write a one-page release listing the essential details of the opening.

2) With the release, enclose at least one stunning photo and, if relevant, a bio.

3) Five days after mailing the release, call the reporter and casually inquire as to whether they got the release, and whether they'll be covering the event. If they say they're not sure, tell them you'll check back later.

4) If you haven't heard from anyone within a few days, check back. Don't make a nuisance of yourself, but politely try to get a commitment, bearing in mind that reporters are enormously overworked, with many pressing deadlines to deal with.

5) Send the same information to television stations. If you're in a large city, they'll be less likely to cover the event than in a smaller town, but anything is worth a try.

The reporter or photographer can arrive before the event, or during. If the only time they can come is, say, the day before, try to get them to shoot you as you're installing the work, or touching it up. It doesn't need touching up? Touch it up anyway. Reporters love to catch artists in action. If this is the only way you can get the story, then do what they ask. It helps them, and you.

If they come during the event, they'll let you know what they want to shoot. Never try to dictate a photograph for them.

What if the paper wants to do the story, but can't send out a photographer? Have one of your friends take a shot of you with one of your best pieces, in fact several shots, so you can choose the best one. Why? You're dealing in a visual world. An article without a photo is about as useful as a bike without tires.

After the article appears, cut it out with the date and name of the paper pasted at the top. Then laminate it, and copy the devil out of it—assuming the newspaper has no copyright quarrel with this. Photocopies of articles, when handed to prospective clients or galleries, will automatically give you credibility. You already know that your work is credible, that it is the impassioned result of your talent, and that it reflects years of discipline and hard work. You don't need to convince yourself of this, it is others you're trying to convince. Copies of press—any press—will help do this.

Also place a copy of the article in your portfolio, perhaps on the third or fourth page. The more articles, the better. Just as important, list the occurrence of the article—meaning the date on which it was written, and the name of the paper—on your resume, no matter how minor the coverage might have been.

But what if, after all your efforts, no paper is willing to cover the event? Then you should still ensure that the paper lists the occurrence in their gallery or entertainment section. In fact you should make sure they do this even if they cover the event. If your paper doesn't have any such section, then petition them to create one. It is every paper's obligation to inform the public they serve, and who in turn supports them. This includes art openings, just as it includes book reviews, film reviews, and pundits' columns.

Other events that make for good stories are large installations of any kind, whether in public, corporate or private spaces (more on commissions of this sort in Chapter Eight). Any work of art that is large, be it a painting or sculpture, constitutes a story. If the reporter you approach doesn't want to cover the installation, try others until you get one who will. Again, work with television stations as well as newspapers.

My gallery routinely installs large sculptures and paintings for a variety of clients around the country. Out of habit, I regularly involve reporters in these stories. I send them to the artists' studios while the works are being created, and then, if we're installing locally, I send them to interview the artist as the piece is being hoisted into place. If the installation is to take place somewhere across the country, I simply contact the media in the region where we're installing. Nothing impresses my local clients more than an article from a major paper in another city.

Apart from works that we sell to private collectors, I suppose my gallery is best known for the massive bronzes that one of my sculptors—Jim Brothers—created for the National D-Day Memorial in Virginia. I was the art consultant on the project, and devoted four years of hard work to seeing it come to fruition (although the hours I put in were nothing compared to those of Jim's).

These monumental bronzes, of historical significance and sculptural drama, facilitated our getting press with papers and magazines all over the country: the Associated Press, *The Washington Post*, *People*, *National Geographic*, *The New York Times*, etc. But none of these articles would have been focused on our efforts if I hadn't spent untold hours contacting reporters, doing the follow-ups, and follow-ups to the follow-ups. Because I took these essential steps, we received the recognition, and future contracts, that we deserved.

You should never let a large installation of any kind pass without attempting to get the press to cover it. Only in this way will you get the credit you're due. And if things go well, you'll very possibly get more business.

### Postcards and Newsletters

I've written this section under the assumption that you're not yet in a gallery. If you are in one, just follow their lead on this issue; they'll likely know how to handle it. If they don't, you might have them read this book.

Postcards, like copies of articles, are a very useful promotional tool. All you need is a well photographed slide of a strong work to produce one. Most printing firms, and postcard companies, can help you with layout. I tend to prefer companies that specialize in postcards, since they're often the cheapest.

On the front of the card, the most important thing of course is the image, and the quality of the reproduction. Assuming that you do have a good image, you have two choices: put your name in large letters above the work, with title, medium and size in smaller print below; or print the front as a full bleed and put all the information on the back. In my gallery, until an artist is established, we always put their name on both the front *and* back. This helps clients to understand, at a glance, who did the work. Later, after you've achieved your initial successes, you can opt to have the name on the back only.

On the reverse side, whether or not you print anything on the front, you'll need your name in large letters, and beneath that the contact information. If there is room for a brief bio, then that can go beneath the address and phone number. Use the format I've laid out if you like, but whatever format you use, please be careful to not place your address in the lower section of the card; if you do, the postal computers may read this as the mailing address,

and send it back to you. In fact, according to postal standards, you must leave the lower 5/8" of the entire card blank.

Below is a basic layout for the reverse side of a postcard. Use this in any way that it is helpful to you.

Your Name
Street Address
City, State  Zip
Phone #
web address if applicable

Title, Medium and Size of Work
(if not listed on the front)

Brief biographical paragraph if
beneficial (40 words or less), or
description of show.

You do not need to have a major show under your belt to qualify for printing postcards. You don't need to have landed a significant commission, or to have sold the work pictured. You don't even need to be established. All you do need is one or more pieces that you feel represent you at your best.

The same applies to newsletters. Of course in order to warrant printing a newsletter, it's best if you can provide your readers with some actual news. Don't worry if your career isn't that advanced yet; those things will come in time—*if* you're dedicated. Besides, the bulk of all newsletters are composed partly of fluff. Their only purpose, really, is to inform prospective clients and galleries that your career is advancing. You don't care to write one? Perhaps you'll eventually join a gallery that already does, and that will include you. But whoever writes it, make

certain it's brief, based in fact, with crisp images and an impressive layout.

The point is, whether you utilize postcards, newsletters, or both, the printed word, when married to impressive images, is a powerful combination. By handing these to prospective clients, you'll find that you look established, and *feel* established. I advise you do this early in your career. It will become a good habit, and a worthwhile one, especially when dealing with the public at art fairs and juried shows.

What about those art fairs? When will I discuss them, and how to get into them, and whether they're worth the bother? Why, in the next chapter.

# FIVE

## *Art Fairs & Juried Shows*

Like artist's statements, I consider most art fairs a waste of time for the serious artist. And, like artist's statements, you will in all likelihood still have to do them. I've done them. Most of my artists have done them. Most artists I know have done them. They provide you with those necessary lines for your resume, and you're going to have to have plenty of those lines before any of the better galleries will consider your work. For those of you who only execute installation-based work, or work that is strictly avant-garde, art fairs are of little relevance. But for the purpose of general knowledge, you should read this section anyway.

Just what is an art fair? Usually an outdoor event arranged by well intentioned dilettantes for a largely indifferent public. Are they all this bad? No. Certain of them are excellent, and couldn't be better venues for your work, or for meeting potential collectors. The trick is learning to choose between the ones that are worthwhile, and the ones that aren't.

The best story I ever heard about an art fair came from Vernon Brejcha, a glass artist whose works have been placed with museums worldwide, but who in the beginning was as unknown as any emerging artist. He told me how once, in the early '70s, he was sitting in a booth at a

show in Dallas when a man, a woman, and their daughter walked up. The trio stared at his glass, stared at him, then the father said to the girl: "See now, Charlene. This is how you'll end up if you don't start getting better grades." They turned and walked off.

Vernon was rather more selective in choosing his fairs after that.

Regardless of whether the show is an outdoor fair or an indoor exhibit, it must be juried. It means nothing for you to be accepted in a non-juried exhibit. What's more, in non-juried shows you don't know what other kinds of work will be exhibited, or whether you'll be stuck next to some guy who does paint-by-number landscapes on saw blades.

Amusingly, the jury members in juried shows are sometimes no more qualified to serve on these panels than the average car salesman. In fact they may have almost no background in art, but are simply chosen because their niece is chairwoman, or they think it would be a "creative" thing to do, or, better yet, they're trying to expand their horizons. It could be worse. The panel could choose to not have a show at all. In certain cases this would be a blessing, but often it would not, since the more sophisticated of the juried shows do help advance the awareness of art. Besides, if you win a prize they usually give you a little dough.

I therefore repeat, ANY SHOW OR FAIR YOU ENTER MUST BE JURIED. So much the better if it's a well-established venue with a jurying process that is respected, like the Navy Pier Shows in Chicago (if you can afford the booth fees), or, in the more typical realm, the Plaza Art Fair in Kansas City. But even if it's a newer show that doesn't yet have a reputation, as long as it's well-run, well-attended and in a proper setting, this is better than letting your work sit in the studio and collect dust. You're in the process of building up your resume. It's a gradual process, and you'll have to be patient in carrying it out.

## *How Do You Learn About the Shows?*

All states and major cities have arts commissions; many smaller cities have arts commissions. Most of these have listings of shows that are held in their region. Call or write the arts commission of the cities you're interested in, and ask for a listing. Also ask to be put on their mailing list. Their mailings will keep you informed of upcoming shows, as well as of various commissions that may arise.

The College Art Association, which is represented on most campuses, can also provide you with lists of shows that occur nationwide. Many of these can be worth participating in, if only in the sense of adding to your resume, and your credibility. Investigate them, and decide which are appropriate for you.

In the same vein, most cities have an artists' coalition or association. These too will have listings of various shows, especially those held in nonprofit or cooperative galleries. These shows can be quite worthwhile in terms of meeting folks who can be of help to your career, such as established artists or gallery owners. Like anything else, these can also be a waste of time, depending on the show, its attendance, and how well you handle any opportunities that may arise.

You can also call any of the major galleries in cities where you want to exhibit, and ask them about reputable shows in their area. A gallery director, or assistant director, will often be better informed than anyone else about the viability of certain shows.

The more shows you attend, the more shows you'll become aware of; other artists will help inform you of them, as will show organizers and attendees. Who knows? You might even sell some work along the way.

## *Shows I've Done*

For the first two years that I was in the art business, I worked at it part-time, out of an office in my house.

Because my artists were mostly unknown, and also due to the limitations of my location, I made it a priority to place my artists in certain out-of-state shows. I did this because I realized that local clients would take my artists more seriously if they knew those artists had shown in other regions. The adage that "the genius is always in the next town" bears true weight in the art business. Local collectors will almost never take you seriously unless you've had proven success outside your region. And when the time comes to approach galleries, the same will hold true.

So I sent out all those sheafs of slides to various juries, and got my painters and sculptors accepted in shows in Chicago, Sedona, Denver, St. Louis, etc. As it turned out, getting them into the shows was the easy part. Making profitable use of the shows was another matter.

### A Typical Show

One of the shows we did in Colorado was Sculpture in the Park, in Loveland. Loveland is just north of Denver, and has become a center for bronze sculpting and casting in the rebirth of the figurative movement. Believe me, you can find it all in that town, from the shallowest sort of kitsch to figurative pieces of true power and grace. And it's all pretty much exhibited at Sculpture in the Park, from one end of the spectrum to the other.

So I entered bronzes by Jim Brothers. His work was accepted, we loaded the van, and off we went across the plains, with visions of sales dancing like mirages before us.

The exhibit, as you can likely guess, is held in a park, with the sculptures displayed under a group of massive tents. We were shown where our corner was, set up, and I manned the booth while Jim did what he does best when not sculpting: he went off and drank beer with other sculptors.

The crowd began filing by. They filed by Friday night, all day Saturday, all day Sunday. I talked to several hundred

people over the course of those three days. Many of them took home photographs, resumes, business cards, etc. I later wrote each prospective lead, made the follow-up calls, and in general did everything I was supposed to do. Not a single piece sold.

For the most part, the only artists who were selling were the established ones. While Jim's work was every bit as good as theirs, and in many cases better, we were as yet unestablished, and because of this, his bronzes sat idle.

Ditto the shows in Sedona, Denver, and St. Louis. Some of these shows were dismal affairs where almost no one sold anything, where the crowd filed by and the artists sat in their booths, staring out at the people while they stared back, a gulf of miscommunication separating us. After a day of that I would retire to my van, and try to sleep off the depression that these failures invariably brought on. Then in the morning I would adjust my attitude, say *this is the day*, and go back and do it again. And again. And again.

The fact is, I experienced no significant sales in any of these shows. Not until our last one, an impressive affair in Chicago, did we sell anything—a small bronze that barely covered our expenses.

What did we get out of all that? Expanding resumes, for one thing. Experience, for another. And lots of fine nights with other artists, drinking beer and cursing our fate and having a great time doing it. All those shows, in light of this, were hardly a wasted effort. But by the time I did that last show, I realized I'd had it with arranging exhibits in far-off venues, and dealing with prosperous "collectors" who underwent sticker shock at anything over $500. I decided that from then on I would run my own blasted shows, and that the only time I would move a bronze or hang a painting again would be in my own space. I decided to open my own gallery.

God help me.

# SIX

Before I discuss the placing of your work in the galleries, it would be useful for you to know a little about what it takes to run one. Why? Because the more you know about the realities of the art world, the better you'll understand how you might fit in. The story I'm about to tell you is, like most of what I've written, quite candid. But I often find that the deeper sorts of understanding spring from candor, and, as I'm sure you've already deduced, this book is as much about understanding as it is about art.

## One Gallery's Story

At the time I decided to open a gallery I was living in Lawrence, Kansas: home to the University of Kansas, to William Burroughs (when he was still alive), to Jayhawk basketball, and of course to thousands of college students. In Lawrence—a town that is very much alive—there is a band in nearly every bar, and an artist on nearly every corner. In other words, it's like most college towns.

After two years of running an art business out of my home, I realized I'd have to open a proper gallery in order to succeed. The problem was, I knew nothing about running a gallery. Neither did my artists, but they were very excited about the prospect, and most were certain that we'd make buckets of money.

My decision had been brought on by the fact that, the year before, I'd landed a major commission from G.E. Aircraft Engines, who had ordered some twenty bronzes by Jim Brothers, my lead bronze sculptor. Achieving this, between my obligations as novelist, father and mower of lawns, had been very demanding, but the benefits were profound. After casting expenses, which naturally we'd underestimated, Jim and I realized a reasonable but hardly earth-shaking profit.

My share was quickly eroded by debt, taxes, the cost of raising children, and marketing expenses. Also a week in Colorado with my family. Afterward I had $10,000 left— enough, I convinced myself, to open a gallery and begin my climb toward prosperity.

Jim Brothers, who had been sculpting and starving for thirty years by then, advised me against it. He'd seen countless galleries go down in flames, and although he was enjoying our initial success, his pleasure didn't override his skepticism. He warned me that while people do need clothes, food and shelter, nobody *needs* art, hence the limitations of the market. He knew the odds I would be up against, especially opening in the Midwest, and didn't want to see me go broke. His advice was to keep mowing lawns, and keep selling art out of my house.

I thanked him for the advice, but all my instincts told me I had to move on. They also told me that somehow things would work out, and that I would be guided through all of it, if I could just stay in tune with my intuition. I trusted that I would.

My wife trusted the same when I told her my plan. She wasn't sure if a mere $10,000 would be enough to open a gallery, but she believed that somehow we would make things work. Even so, there was no way I was going to open a gallery in a town of only 90,000 people. It simply wasn't large enough. We knew we would have to move to

Kansas City, a town of over a million, if we were to stand even the remotest chance of succeeding.

So in short order I found a space, we sold the house in Lawrence, bought the one in Kansas City, and the entire adventure—although some might call it a nightmare—began.

## How it Started

The Hotel Savoy, at that time, was a faded old joint that housed a glorious old restaurant: the Savoy Grill. Since 1904, Kansas City's elite had been chomping on lobster and chateaubriand among its white tablecloths and leather booths. The meals were excellent, the service understated, and the prices well above moderate. A joint like this, I figured, would host the right clientele for a gallery. So I talked the hotel owner into leasing me the abandoned barbershop, which was adjacent to the restaurant.

It was a great space: a large room with a high ceiling, high windows, good light, one set of doors that opened onto the street, another set that opened onto the lobby, and a little loft in back where I took my afternoon naps.

I set about remodeling it, hanging the track lights, hanging the signs, and, finally, hanging the paintings. I did it all in January of 1994, and by February sent out the press releases, ran the ads, threw open the doors, and waited for the throngs of a grateful city to enter and buy.

Three months later my banker called to inform me that I was overdrawn by $5,000. What he didn't know, but what I knew all too well, was that I owed an additional $3,000 on ads and various expenses. By this time I had sold three paintings for a total of $4,750, half of which I kept, the other half going to the artists. All of that money had already been spent just keeping the gallery open. The buckets of money we'd hoped for were turning out to be teaspoons.

My banker, a very patient man, asked me if I had any contracts pending. I told him I did.

Fortunately I had just landed Jim Brothers a commission to execute a monument of Omar Bradley, a beloved general of World War II. The fee we were to be paid was $95,000—a huge sum for us at the time. I was to make $25,000. My banker, enormously relieved to hear this, advanced me $10,000 against the contract. The loan kept my gallery open, and me afloat, but also initiated me into the world of multiple debt.

I thanked my banker, hung up the phone, and tried once again to devise a marketing plan for selling original art, because the art simply wasn't selling. I had to try to determine what I was doing wrong.

The problem was, I couldn't see anything that I was doing wrong. I had run ads in the best magazines, my gallery had been written up in all the papers, my location brought in abundant traffic, and yet no matter how many people came through the door, almost no one bought—despite the fact that most of them loved the work. I didn't get it. Grocery stores ran ads and made money. Clothing stores ran ads and made money. Realtors ran ads and made money. I ran ads *and* got in the paper *and* on TV . . . and nothing happened. Oh paintings sold here and there, but the sales were so few that, at the rate I was going, I would have to close in two more months. I didn't get it. I just didn't get it.

Finally I got tired of trying to get it, put on my inline skates, put the Gone Fishin' sign on the door, and went out into the warmth of the April afternoon. With my shirt off I skimmed away through the streets, cutting between the cars, gliding down to the River Market, back up to Allis Plaza, then farther up to the Lewis and Clark bluff, to sit panting among the hip hoppers and their booming cars, to look out over the great river, and wonder what the hell I was doing in the art business.

Then, sweating, I glided down the hill to the gallery, to open back up and wait for the diners from the restaurant to come in, and to try to coax them into buying. Many people would come in; none would buy. I would work until ten nonetheless.

By ten-thirty I would normally be home, and my wife would be up waiting. My kids, whose little lives were passing by while I worked fourteen-hour days, would be long asleep. I'd kiss each of them in their beds. My wife would watch as I kissed them, then take me to our battered sofa so we could talk, and so I could slam a whiskey or two, which I was beginning to do a little too often.

We would talk about her day—she ran a day-care out of our house—and we would talk about mine. I never told her how poorly things were going, and didn't see why I should. Causing her to worry wouldn't help the gallery. No, those problems were for me to bear. She had enough to deal with, what with the drafty old house, a gaggle of kids to sit, meals to cook, etc. There was no way I was going to add to her burden. So whenever she asked how the gallery was doing, I always told her it was fine. Then, if it was near the first of the month, she would ask if I had enough money for the mortgage and bills—another twelve hundred dollars. I'd just slam the whiskey and say, "Sure."

My wife would sense my tension though, and ask if there was anything she could do.

Upstairs I'd lie on the bed as she spread a satin sheen of oil across my shoulders, massaging hard then soft then hard again, the touch of her hands making all my worries disappear. I felt those hands and thought of her, thought also of my children asleep in the next room, and of the risk I'd placed them all under. Somehow I would have to make the gallery fly. For their sake, I vowed to.

Afterward, I always massaged her.

In the morning I would rise early and go off and do the shopping. By the time I got home with the groceries, my wife and kids would be up. The kids and I would play together briefly before I left for work. Then I would kiss the kids, kiss my wife, and return to the gallery to do it all again, trying to remember that I should be grateful for this opportunity, trying to learn from each mistake. I don't know that I learned each time, but without doubt I was learning.

*Business debt now at $15,000. Other debt, excluding mortgage, roughly the same.*

### Some of My Artists

Jim Brothers: Jim looks like a cross between Buffalo Bill Cody and Stephen Stills. A war protester during the Vietnam era, more than once he was clubbed over the head by pro-war cops. He has big hands and warm eyes and a figurative ability with monumental bronzes that, in my opinion, is among the best in the country. My job was to convince clients of the sheer power of his work, and also to convince him that, no matter how broke we were, or sometimes how depressed, that power was always in him. It's not that he ever doubted this, it's just that, as with most artists (and writers), he on occasion needed to be reassured. It was my job to reassure him, and to get him commissions. I would do both.

Tyler Lyke: Although living in Philly now instead of in my region, I've been affiliated with this guy for ten years. He started out working in flat glass, assembling pieces from broken shards that had been painted in primary colors, with the jagged edges wrapped in copper foil. The result was stunning, and I placed several of his works. Then he changed his style, and medium, to acrylic paint over heavily gessoed panels, with emphasis on miniscule abstracted detail. His discipline is as great as Jim Brothers',

but in a different way. I've always felt that the future holds great things for Tyler, but lord the dues he's had to pay.

Kim Casebeer: Since I first opened my gallery, I have been approached by a variety of pastel painters—none of whom I chose to represent because their work struck me as uninspired. Then Kim came along: quiet, shy, totally lacking in pretension, and the best pastel artist I have ever met. She paints primarily landscapes and figures, hauntingly understated, with a vagueness that speaks of supreme intelligence and skill. Her pastels actually have depth and texture—a rare achievement—and the majority of my clients are drawn to her work, especially women. Twice she juried into a pastel competition in New York, and won an award each time.

Arlie and Dave Regier: In his seventies now, Arlie is the unassuming leader of this father/son studio, and has achieved career goals that most artists only dream of. Always kind, always humble, he creates contemporary sculpture in stainless steel that is of a craft, and uniqueness, that you would never believe comes from this quiet, unassuming soul. Arlie's career took off late in life, when he was fifty-nine. Soon afterward Dave joined him. With me providing feedback, and Arlie and Dave busting their butts, I would eventually place their works with collectors nationwide, and help them gain a very active following. In those early days we knew this was possible, we just didn't know if we could pull it off.

Vernon Brejcha: A highly disciplined glass artist, Vernon has been involved in the contemporary glass movement from its start in the late '60s, when he studied under Harvey Littleton. Eventually he would place works with the Smithsonian, the Kunstmuseum in Dusseldorf, the L.A. County Museum, etc. He knew everyone in the glass world, and understood things about its intricacies that I would be years in learning. He didn't need me or my gallery, but I needed him, and he agreed to let me carry his work.

Phil Epp: Phil paints surreal Western landscapes that seem larger than life, and yet are curiously intimate. The colors—purple and peach and blue and gold—tend toward brilliance, and the perspective is pleasantly warped. Eventually one of the head honchos at MGM would collect his work, as would several other California collectors, along with collectors in most major cities. But that was a long way off yet. When I first met Phil he was teaching junior high art to survive, and raising quarter horses in the Kansas Flint Hills, gradually nearing the end of his long struggle to succeed as a painter.

Phil Starke: A plein air painter who interprets mood and light with exceptional skill, Phil captures landscape dramatically while avoiding sentimentality—essential, in my opinion. He has a large following in my region and in California. A flawlessly kind and patient man, Phil is as respected as an instructor as he is a painter. Initially trained at the Chicago Art Institute, he also studied at the American Academy of Art. One of my best muralists, he's executed large works for a variety of hotels, restaurants and banks.

Erin Holliday: The only woman I ever met who is a better carpenter than I, Erin has a feel for lighting, coloration, and translucent materials that allows her to infuse her illuminated works with a surreal quality. She came to me by way of Arkansas, carries herself with quiet dignity, and has powers of observation that regularly rival my own (and to which I'll never admit).

Wolfgang Vaatz: A man of quiet wit, this German-educated sculptor is far more an international soul than he is European. He works in stoneware and, with his enormous kiln, creates water sculptures that stand anywhere from three to eight feet in height. These pieces can be of organic design, or geometric, depending on Wolfgang's intent. Whichever the case, the sound of water pouring down their faces is

always dramatic. Over time I would place these works any-where that people needed a soothing presence: law firms, foyers, dental offices, and even a homeless shelter.

Matt Kirby: A gifted Bostonian who migrated here years ago, Matt is one of those rare creatures who was born with the Golden Mean imprinted on his brain: he has an innate understanding of proportion. As a sculptor in metals and rare woods, he creates installations that seem random, but actually are the result of tight discipline and refined tolerances. Consistently he blows away my clients with his ability to interpret their passions in what seems an abstracted form, whether in large scale or moderate.

Stan Herd: Coming to us initially from the western plains, this guy, on sheer guts and vision, pioneered the craft of crop art. This means he basically creates works in forty-acre fields, sometimes hundred-acre fields. He's created installations in New York City, Australia, Kansas, Texas, and so on. In fact Stan was one of the first artists to execute a work for Absolut Vodka. Recently he worked with Bill Kurtis, the Chicago-based broadcast journalist and documentary film maker, on creating a massive piece for Kurtis' Red Buffalo Ranch in Sedan, Kansas. Now Stan's sights are set on a project in Cuba.

Brent Watkinson: A veteran painter who for years thrived as an illustrator specializing in magazine and book covers, Brent has that rare ability to cross over from still life to nude to cityscape. Most artists choose one direction, and try to master it. Brent has somehow mastered three. He teaches illustration in the summers at Virginia Common-wealth University, then spends the remainder of the year in our area, wandering and painting.

Richard Raney: A brilliant young man who was raised by a single mom in a Houston ghetto, Richard some-how managed to advance his artistic vision, and earn a scholarship to the Kansas City Art Institute. A highly

skilled figurative painter, his smooth lines and controlled surfaces are of a maturity that belie his youth.

Allan Chow: Initially raised in Malaysia, Allan has been in America all of his adult life, and he too attended the KCAI. Sophisticated beyond his years for the manner in which he abstracts cityscape and landscape, he paints with a thick impasto that takes years to master, and great patience to control.

Louis Copt: One of those rare people who can somehow smile through every setback, Louie is a veteran painter who really hit his stride in his early fifties, when he began interpreting the prairiefires that burn across central Kansas each spring. The spontaneity and contrast that this theme demanded of him spilled into his other work—which had previously been rather conservative—and transformed him as a painter. It also won him a feature in one of New York's oldest publications, *American Artist*. Just as with his setbacks, Louie smiles through his successes too.

Then there are others.

I've never had any binding contracts with my artists. We tend to operate on the basis of a handshake and a consignment agreement, with the understanding that anytime either party is unhappy, they can terminate the relationship. Once artists join my gallery they almost never leave, but a few have, and I must allow each of them that option, since it's counterproductive for an artist to stay if they're not content. Normally though they seek me out, and want to stay, since they rely as much on my counsel and industriousness as I do on their talent and vision. I like the balance that we strike with those contrasting qualities; so do they.

### New York: What it Means to Us, and You

This is a digression, but a necessary one.

To be honest, it is doubtful that any of my artists will ever be adopted as the latest trend in Soho or Chelsea, which

are tough places to figure, and much tougher to break into. Some galleries there carry magnificent work that, to me, reflect all the values I've in one way or another discussed. Others appear absurd, even ludicrous, in their courting of the avant-garde at the expense of everything else, especially talent. This excessive posturing seems to bear little substance beyond name recognition, money, and some warped idea of celebrity. Talent is often a last consideration in a number of Soho and Chelsea galleries, superseded by what has tragically become a primary consideration—image.

The most curious thing is that, despite its aura of self-importance, this portion of the New York art scene travels primarily in its own circle and has minimal impact on the rest of the country. Soho and Chelsea represent only a small fraction of what is now occurring in the arts in America. And judging from the 2002 Whitney Biennial, where art from many regions outside New York was virtually ignored, I'd say much of the Manhattan scene is still under the delusion of assumed superiority. In truth, the Soho mystique is what it is because of where it is, not necessarily because of what it values. Dealers like me, with the types of talent I specialize in, rely on New York no more than it relies on us. We deal with the remainder of the country.

Too much of Soho and Chelsea have, in my opinion, betrayed too many artistic fundamentals to be taken seriously anymore, often pretending that this is visionary when in reality it was only visionary a century ago, at the time of the 1913 Armory Show. Now it's more like modernist repetition, all too often passed off as sophistication, hiding beneath a veil of snobbery. Sooner or later someone's going to call this bluff. In fact I'm calling it now—not that I'm the first to do so, nor that I'll be the last.

This doesn't mean that Soho, Chelsea, and anyplace else, shouldn't push the limits of what is accepted; limits should

always be pushed. It does mean though that the rest of us don't necessarily look to this aspect of New York for blessing anymore, or consecration, or even approval. Mutual respect I'd be willing to settle for, assuming it's earned on both sides.

What does this have to do with the story of my gallery? Nothing. But it has a great deal to do with the story of your career, since many of you may not be acquainted with the New York scene, yet will be curious about it, if not intimidated. I'm just giving you a brief introduction, and assuring you that your success can mirror or even eclipse ours, with or without New York.

But none of these opinions intrude on my love for Manhattan, and the four surrounding boroughs. I owe New York a great deal, since my years in and around the city had a profound influence on me. That's why it hurt so deeply to go back in September, 2001—a return that was less like a homecoming than like going back to a place that had once been home, then returning to find it had become a battlefield.

The strange quiet of the city, the sense of sadness, and the look almost of shell-shock on many of the faces. And yet also the compassion, the unity, the newfound levels of patience and consideration: horns that honked less; people saying "please" and "thank you," many of them with subtle warmth.

Then my visit to Ground Zero: the mile-long line of dump trucks, the barricades, the solemn crowd, many of them praying: Christians, Hindus, Jews, Muslims. And posted on windows were fliers for the missing: Christians, Hindus, Jews, Muslims. Also atheists, spiritualists, janitors, secretaries, executives, practical jokesters, intellectuals, party animals, firemen, cops, and, undoubtedly, a number of struggling artists.

Then there was the site itself: the shattered buildings, the mountain of rubble, the cranes, dust, smoke, and stench. It

was only as I gazed on it that I realized I was looking at a mass grave.

I had been greatly depressed ever since the towers collapsed; now my depression deepened: the savagery and the loss. I stared at the wreckage and felt so irrelevant: the profession I was born to, and the thing I do. Oh I know it isn't irrelevant, but at that moment I felt only futility. How could anything in the creative world seem worthwhile in the face of this?

And yet it is. Whatever struggles the world may face, life goes on, just as it always has. And as life goes on, so does the work of the artists who examine events, interpret events, and help us make sense of what all too often seems senseless.

I thought of these things as I walked from Downtown to Soho, passing fire stations and police stations with shrines to the dead out front. At Spring Street I stopped at a cafe. The waitress was friendly and the busboy polite (I had to keep reminding myself that this was New York). The busboy, obviously of Arab descent, was singing along with John Lennon's *Imagine*, which was playing on the radio. He finished with the lines about the world living as one, then kind of stood there.

I asked the waitress if she thought he was much of a singer. She gave him one of those New York grins and said, "Neah."

He just smiled and went back to work.

I drank a cappuccino, wrote some postcards, and left.

That afternoon I caught my plane and flew out over the city, where smoke still spired up from the ruins. I knew in time that New York would be New York again—with all that is both great and awful about it. In the end it still is one magnificent town: so American, so full of excess, at times trend-ridden and self-obsessed, but always incomparable. In the end it has dignity, resilience and strength.

This country wouldn't be what it is without New York, and neither would the arts. I always remember that, just as I also remember to keep it in perspective.

## Trying to Survive

The large sculpture commissions that I began to specialize in served several purposes: they memorialized certain events and figures in history, they showcased Jim Brothers' figurative talent, and they saved my financial butt. They were never lucrative enough, in the beginning, to get me out of debt, but were always sufficiently profitable to allow me to stay in business while gradually going deeper in debt. Over time they would become quite lucrative, especially as Jim and I developed a national reputation for monumental work. In the beginning, though, the commissions were few and the pay below average. Over the course of my first three years in business, I pursued some eighty different figurative commissions, with all the complications that each proposal involved. Out of those eighty, I landed just three contracts.

The first of those was for placing a monumental bronze in Griffith Park in Los Angeles; the second was for a monument of Mark Twain in Hartford, Connecticut; the third was a commission for a ten-foot sculpture of General Omar Bradley in Missouri. The combination of these projects would eventually lead us to commissions of a scale, and a visibility, that until then we'd only dreamt of. But those bigger commissions were still a long way off, with many trials and errors separating us from them.

The Twain story is an odd one. It involved my sculptor being "commissioned" to execute the monument for some businessman in Hannibal, Missouri. Jim had negotiated the contract before I'd taken charge of his career, and priced the piece at $20,000. As a consequence, he was making about three bucks on the deal. He was also pay-

ing for all materials up front, the businessman having advanced him nothing.

Jim set to work. What emerged after one year of struggle was, in my opinion, the finest monument of Twain yet to be cast. It showed Twain's mischief, his latent bitterness, his intelligence and scorn. It also paid homage to Michelangelo, with Jim sculpting the torso in a way that was similar to the "David." The piece was brilliant. Inevitably the businessman, of a variety that I tend to refer to as Neanderthal, didn't want to pay for it. He wanted to renegotiate the deal, or the price, or I don't know what.

Jim went through the roof.

When he came back down I told him I thought I could sell the piece to the City of Hartford. Twain had written his most famous novels while living in his mansion there. I knew Hartford didn't have a monument of him, and suspected they would want one.

I sent photos of the work to the director of the chamber of commerce, and told him the amount that I wanted for the piece (considerably more than $20,000). He loved it but didn't have any money budgeted for the acquisition. So, instead of giving up, he contacted a local businessman, of a variety that I tend to refer to as enlightened. The businessman loved the sculpture too, and said he would be happy to pay for it.

We unveiled the monument on a sunny November afternoon at the downtown library. For a day Jim was a hero to the city while I, the agent, stood in the background and smiled. The director of the chamber was good to us, the journalists were good to us, and so were a number of my old Connecticut friends, who took us out that night for a celebratory dinner. Jim and I caught our plane the next day.

The Twain? To this day that piece is revered in Hartford, or so I am told. The only thing we regret is that Jim

made it life-size, instead of larger-than-life, so that it looks somewhat diminutive amid the streets and skyscrapers of downtown. But don't tell anyone in Connecticut I admitted this; I want them to go on loving the piece just the same.

After my first year in business, walk-in traffic gradually—very gradually—began to increase. My ceaseless marketing had helped. So had the many stories the papers had covered for us: on the Twain monument, the Bradley monument, and a handful of minor installations. I'd sent out press releases to make sure that the media was informed of every event, and they'd responded well. I have to say we had very good coverage.

As time went by, I began to meet some of the wealthier people of the city. A few of them bought work from me; most did not, reserving their business for the galleries in New York or Chicago. Eventually I would bring these collectors my way, and convince them that we were doing work just as sophisticated as that found in the bigger cities. But in the beginning, they scarcely paid us any heed. On the rare occasions that they did, certain of these multimillionaires almost always wanted discounts—a not entirely unpredictable attitude. My artists and I were broke, and desperately in need of sales, so of course I gave them the discounts. But it rankled me.

Conversely, people who were only moderately wealthy almost always paid the listed price. They seemed to understand that I was in a tough business in a city that, like most small cities, didn't care a hang about art. These people loved art, loved coming to the gallery, loved going to the artists' studios even more, and were always happy to pay what really was a fair price in the first place.

People like these: The Kansas City housewife who fell in love with an abstract oil, but didn't have the $2,400 to pay

for it, so she paid it off in installments. The Topeka contractor who was mesmerized by a steel interpretation of a grain elevator, who looked at the $2,600 price, said, "Hell, it's worth it," and wrote me a check. The woman lawyer who came in each May to buy a painting, who always paid full price, and who had a quietly casual way of flirting as she did. The New York business consultant who regularly came to Kansas City, who over the years would buy over a dozen pieces, and who was both knowledgeable and generous.

Clients like these helped keep my leaking gallery afloat, which was better than foundering, but I still had no money in the bank, and was only one step ahead of the creditors. Then there were my credit cards, which I'd had to use to pay income tax, and which were spiraling out of control. In other words, sales and commissions would have to at least double in order for the gallery to survive. Everything I had tried—more ads, more mailings, more shows—seemed to have no effect. Still I went on trying, hoping that something would eventually turn the tide.

*Business debt now at $25,000. Other debt: roughly the same.*

Because I was next to the Savoy Grill, but outside its frantic pace and tensions, the people who worked there often came by to visit. The black chefs, the Hispanic waiters, the gay and straight waiters, the busboys and managers. All of them came by to soak in the calm of the gallery, and to just relax.

The majority of them, like most people, were intimidated their first time in, professing that they didn't know anything about art. I told them that that was nonsense, that all they had to do was look around and pick out what they liked. They didn't need to know why they liked it, or what it was about, they simply had to respond to it.

When I gave them this formula, a new confidence would form in their eyes, and they would walk around telling me why they liked this, and why they didn't like that. It was good for them, good for me, and I enjoyed watching them do it.

There were dozens of others to whom I extended the same advice: office workers, warehouse workers, software programmers, and the occasional executive. They would come into the gallery, look at the art, forget about the working world for awhile, then later go back into it, but with an altered frame of mind. They all assumed of course that I was growing rich, sitting behind my desk, making phone calls and writing proposals. What they didn't know was that most of them made far more money than I.

## My Own Work

The gallery did two things for my writing: first it stole from it, then it fed it. Initially I was so busy I had no time to write. For a full year I didn't write, which was very hard for me, and built up a lot of internal pressures that I had difficulty bearing. Then a book burst out of me in a way that no book ever had before, and, despite the dire state of my finances, I felt fulfilled again. Not fulfilled in the way that my children's laughter, my wife's touch, or long trips alone fulfill me, but only in the way that artists truly can be: by doing their best work.

In the mornings I would come in, look at the sunlight as it lit the paintings, and with the glow of that color around me, I'd set to work, writing for maybe three hours before people began wandering in, or the phone began to ring. Then I'd concentrate on gallery business until late at night, knowing that my real work had been done, and that I could go back to it the next day, and that it would still be there, waiting.

That book, my fourth, was a breakthrough work for me. In writing it, I learned more about how I wanted to handle

prose than I ever had before. I even sent it to the literary critic for the *Kansas City Star,* Theodore O'Leary, who called to congratulate me, and invited me over for drinks. He wasn't sure if the book would get published in today's parlous market (it didn't), but he felt it showed great promise, and urged me to stick with it. I told him I would.

It would be two more years before I'd land my first agent, but after Ted's encouragement, I knew I was on my way. As with most artists there was no course I could follow, and no map, but I believed my intuition would guide me, and that hard work would pay off. Deep inside, in that place where our dreams live, I could feel the certainty of it. That wouldn't make the coming hurdles any easier to cross, or the pressures easier to bear, but it did give me hope in those times when things often seemed hopeless. What I didn't know was that the feelings of hopelessness were far from over; in fact the worst of them were about to begin.

My gallery by now was two years old, and I at last had a reputation of sorts. Many people recognized the gallery's name, and even seemed to respect it. Scores of these people would come in to visit, to browse, to satisfy their curiosity; as usual, few would buy. All the other galleries in the city were convinced I was doing a bang-up business. In reality I was at least as broke as they, and often more so, since many of the other galleries were underwritten by wealthy owners. I was still slowly, inexorably headed for bankruptcy, with apparently no way to stop it.

No matter how hard I worked, I couldn't seem to break through that middle-class attitude in America, where so many of the prosperous spend hundreds of thousands on their homes, their cars, their lawns, then put framed posters on the walls for art. Regardless of their income level—the upper class included—this tends to be the overall practice.

And if you think this is just a Midwestern phenomenon, I've got news: it ain't.

It isn't that the average American doesn't enjoy real art, they're just too busy, or self-absorbed, or indifferent to recognize it. If I can help them see it when they come in the gallery, frequently they'll become impassioned about it—assuming they're open enough to see things at all.

Even if they can't afford the work, helping them respond to it is my first priority, even ahead of sales. The difficulty lies in getting them in the door, and getting them to slow down long enough to comprehend what it is they're viewing. I've gotten very good at helping browsers do this over the years, and increased sales have accompanied that ability. But in the early years I still had much to learn about the process, and the resulting poor rate of sales was driving me mad.

What also drove me mad was the fact that the most prosperous gallery in the city sold work that I felt was mediocre, and they sold it like candy in a dimestore. In this gallery machine-produced canvases passed for painting, and sentimentality for depth. The works were uninspired, flat and shallow. But because the gallery owners hobnobbed with the city's elite, they never lacked for buyers. Their openings were always packed, with everything selling off the walls. My openings were packed too, mostly with wine-sipping bohemians who loved the gallery, and loved the art, but could afford none of it. Consequently I held several openings where not a single work sold.

The lesson to be learned? Connections will sell anything, including bad work. I had no connections. I had a small but growing list of clients who trusted me, and I trusted them. Initially I had thought that would be enough. It wasn't.

It was at about this time that a large jug of bourbon began to appear in one of my desk drawers. It would show

up on Wednesday and be emptied by Saturday night. I never hit it during the day, but in the evening as diners filled the restaurant, and gallery, I'd take snorts off that sucker and watch the non-buyers file through. I was going broke, I was enraged at the position I had placed my family in, and at thirty-eight I still hadn't written a novel of the power I was trying to attain. That's what angered me the most. I blamed myself, I blamed the art business, and especially I blamed the crowds of non-buyers who took up my time. I had begun to despise them:

A wide-eyed suburban woman coming through the gallery, staring at all the work without seeing a single thing, then turning to me and saying: "Oh my. Did you do all this?"

Me sitting at my desk, my feet up, my shoes off, a glass of bourbon in my hand. "You bet, ma'am. I painted every painting in here. Did the sculptures too, but only in my spare time."

Still the wide eyes, the kind but vacant expression. "Ohhhh. You must be very creative."

"Why thank-you, ma'am. I sure try to be."

Or a gaggle of similar men and women, squinting at the work and muttering among themselves about the prices, one of the men finally turning to me and asking the same question that the suburban woman had.

Me blearily looking up, taking a sip of bourbon, and saying, "Buddy, I couldn't draw flies with my shoes off."

All of them filing out in bewildered silence.

Or the occasional New Yorker, Texan, or Kansas Citian who was a serious collector, but me often too embittered to give them appropriate attention, they sensing the bitterness, and leaving as quickly as they had come.

I would think of opportunities missed, of opportunities that never came, and soddenly go home to watch a movie with my family. My kids on my lap, too young to realize my condition, me holding them as they watched *It's A Wonderful Life,* with me weeping inside for the thing I'd done to their future. Me thinking about my life insurance policy, wondering if they'd be better off. And don't think I didn't consider it, but as I said earlier, I'm just not made that way.

My wife watched all this from aside, uncertain if she knew me anymore, and a little afraid of who I was becoming. A wall of miscommunication had begun to descend between us. She felt it. So did I. Neither of us said a word about it.

Owing to stress, overwork, and looming financial disaster, I had begun to forget to do the little things: soft words, caresses, the taking of walks, sitting and talking, flowers for no reason, the occasional seduction before the fireplace, phone calls midafternoon just to ask how she was, what she was doing. I had begun to forget those things, and so had she. I knew then that our marriage, and my gallery, would either have to undergo an evolution, or not. The problem was, I didn't feel capable of an evolution, either within myself or without. I needed one though. I needed one badly.

### Evolution Comes Knocking

I'd like to write in detail about this occurrence, but out of respect for my wife, I can't. It's too painful for her to be reminded of, and in fact is something she would just as soon forget—even though I was the one that it happened to. For that reason, I'll not go into any details.

Suffice to say it was a traumatic event that deeply affected our lives, and, indirectly, the lives of our children. It added immeasurably to the many burdens I was already under,

caused me to have brutal migraines for three years, and briefly swayed me toward the contemplation of violence against certain parties—in other words, I was tempted to beat the living hell out of them. But I am in truth not a violent man, so this really wasn't an option. Instead I retreated back into my tendency toward compassion and understanding, despite how enraged I was over the event, and what it did to my family. But even this I eventually had to forgive, since if I hadn't, my rage would have eventually destroyed me, and my work, and would have harmed the ones I love.

In the end, the entire episode only deepened the bond between my wife and myself, further broadened my awareness as an artist, and, perhaps justly, brought greater misery down on the perpetrators. In the end, I gained far more from it than I lost. It's just that while I was going through the ordeal, it seemed to be one more needless test in the long line of tests that life is inevitably made up of.

Why mention this at all? To acknowledge that the pressures you're under as an artist are harsh enough already; you don't need any other pressures. But just as with everyone else in this world, you will encounter additional burdens. Perhaps that is life's way of teaching you: just when you think you can bear no more hardships, an entire truckload is dumped on you.

Why? I suspect it has something to do with developing tenacity, and inner strength, meaning that if you handle things well, you'll deepen those traits, and likely gain wisdom in the process. You can also gain hatred and anger. As with most events in life, it depends on how you take it. I hope you learn to take these things with grace, balance and courage. That should stand you in good stead for the day when things really get tough.

Just remember, the song of life is partly one of adversity. If you can accept this now, it will make your road much easier. If you cannot, the journey may well become a disaster.

This particular disaster hit me and my family in the spring of '96; we recovered, and went on. It was a hell of an evolution to go through, and a hell of a time to go through it, but that's how the cards fell. By the time I had begun to resolve the mess, Christmas was upon us. I profited from the season as best I could, gave to various charities what I could, and spent the rest on my family. It was a modest holiday, as ours normally are, but even so it was a wonderful diversion, and allowed me, for a time, to forget that my gallery was still headed for bankruptcy, and my debt still deepening. Thank God for holidays.

After New Year's I forced myself to confront gallery business once more, and to deal with everything before me: proposals that I had to prepare, mailings that I had to stuff, marketing for the spring shows, and, as always, the general disaster of my finances.

While the Christmas season had been the best I'd yet known, the profits were not sufficient to override the losses of the year. As for January and February, they had been busts. For that matter, most months were still busts. I was hoping things would be better in March though. After everything I'd been through, after all the thousands of doors I'd knocked on and been turned away from (though some had opened), I felt it was time for things to improve. I had owned the gallery for three years now. I felt I was ready for a change. My intuition kept assuring me that March would bring a change. It did.

On the first Sunday of March, I got up at dawn and drove down to the East Side ghetto. There I cruised among the old apartment buildings and projects, the derelict storefronts, the sleeping viciousness of the streets. Only the churchgoers were awake at that hour, where in the Pentecostal churches they had already begun to gather and

sing. Otherwise the ghetto seemed vacant, except for the odd prostitute or crack addict, wandering the frigid sidewalks, probably not having yet been to sleep.

I looked at the destitution of the place, and thought of how most of these people had not been born with the opportunities that I had. I thought of how different our lives were, and how minor my struggles compared to theirs. Surely I could rescue my situation if I just worked hard enough, and rose up out of my self-pity. Yeah, things had been tough. Yeah my debt, and the struggles with my writing, and that whole other mess, had taken a toll on me, but still I knew things could get better. I could figure a way out of this. All I had to do was employ greater inspiration, and not lose sight of my vision. If it could be done in any country, it could be done in this one. Well then, I would do it.

I drove around for a couple of hours, getting out a few times to walk the streets, to feel the desperation, and to feel how grateful I was that I hadn't had to start life with all this against me. Next to these people, I had things easy. I had it made.

Feeling somewhat less depressed, and trying to feel elated, I drove on to the gallery to do my morning's writing.

As I worked, I thought how I had to turn this whole thing around, and would, no matter what. Somehow, I would find a way. I knew now that I could.

### Turning Things Around

That night, the hotel manager called me at home and asked if I was watching the news.

I told him I wasn't.

He told me that was good.

I asked him why?

He said because my gallery was on fire.

I let the words sink in to be sure I understood them, but of course I didn't really understand them, so he said it

again. He paused, and as he did I could hear men shouting in the background, the sound of gushing water. Then he said that I should probably come downtown.

I told him I'd be there in thirty minutes. I made it in twenty.

I parked down the street from the hotel, beyond the yellow-taped cordon, and walked up among the fire engines, firemen and cops. Smoke was billowing out the gallery door and water was pouring down the steps. When everyone realized that I was the owner, there was quiet commotion and words of condolence. Then a platinum blonde with thick makeup, a microphone in her hand, and a cameraman at her side walked up. She asked if I wanted to be interviewed. I looked at her tense, career-driven face and told her, no, I did not want to be interviewed. Then I went inside to look at the gallery, or what was left of it.

The fire had started in the storage room behind my space, caused by a carelessly left cigarette. It destroyed the storage room, the room above it, and half of my gallery. Most of the paintings and sculpture, thankfully, had been moved out by the firemen and hotel staff. Though smoke-damaged, those works had been saved. Everything else—furniture, files, my computer—was ruined. I looked around at the mess as one of the fire captains came up.

He expressed his sympathies. I thanked him, and thanked him also for having moved out so many of the paintings; he acted like it was nothing. Primarily he was concerned about the damage to the gallery; he told me that he sure hoped I had good insurance.

My insurance policy had lapsed three weeks earlier, since I'd opted to pay the phone bill, an overdue advertising bill, and two months of back-rent instead of the policy. I had been planning to catch up on the policy in another week.

I told him, you bet, I had real good insurance.

When I got home my wife asked if everything was okay. She was sitting up in bed looking nervous and worried, certain we'd been ruined. I told her about the damage, and the extent of it.

She asked if the insurance would cover everything.

I told her sure it would: that it would pay off the debt, allow me to open a new gallery, and that everything would be just fine.

She kept watching me, as if trying to make certain that what I said was real. My expression betrayed nothing.

Finally she smiled, and said she was glad that everything was all right. Just watching the relief on her face was worth the price of the lie.

Later she went to sleep and slept very soundly. I got to sleep at maybe four, getting up at six to go downtown and face the mess I'd gotten us into.

The damage came to $40,000, more than enough to square my debt and set me up in a new space—had I only been insured. My gut wrenched in triple knots when I thought about it, but there was no point in thinking about it. What was done was done.

I set about cleaning what remained of the gallery, trying to figure a way out once more. While I was cleaning it, most of the other gallery owners in the city called to see if I was okay. I thanked them, and told them I was. Friends called, artists called, then one of my sisters called. A skilled businesswoman, this sister is always boiling with ideas. As we talked, she told me the fire had been necessary.

I asked her to explain.

She said it was simple, that my fate was trying to tell me it was time to move on and start over. She said I wasn't making it where I was, and that the fire would force me to move someplace else, and continue growing—if I interpreted it that way.

I told her I could always grow, but that I needed to be able to feed my family in the process.

She said that was no problem, that all I had to do was have a fire sale: clean all the paintings, discount everything twenty percent, sell the inventory, and move on. She was certain it would be a snap.

It wasn't exactly a snap, but I did take her advice. With the help of some relatives and friends, I cleaned the paintings, and repainted and reopened the gallery. Then I called in the press, including the platinum blonde with the microphone. By the time they all came to interview me I was upbeat again, and gave each of them a story on how you can always rebound, you just have to decide that you want to. I told them that this is America, and that you can do anything here—which to me is true.

They loved it. I got coverage in all the papers and on all the TV stations. The sale was a relative success, and with the $12,000 I netted from it I was able to rent a space in a better location. The new space needed a lot of work, so I spent my days running the old gallery, and my nights renovating the new one. My days had never been longer, but I didn't care. I could sense that my life was turning a corner, and was anxious to continue the journey.

One thing is for certain: March had indeed brought a change.

Curiously, the combination of these experiences—and several others—made me a better writer. Those difficulties reawakened a hunger in me, and a lust for life, that the business world had sent sleeping. They made me savagely determined to succeed as an art dealer, and writer. I didn't want those things for purposes of fame; I'd been too humbled by life to even care about fame anymore. I just wanted the success for my family, my artists, and especially because I felt I had something to contribute. I had made so

many mistakes. I wanted to learn from those mistakes, and finish the job I'd started. Perhaps now I could.

*Business debt now $90,000. Other debt: don't ask.*

### The Aftermath

If my experiences made me a better writer, then it's also true that my drive to avoid bankruptcy stoked my writing in a way that prosperity never could have—the way your own difficulties can also compel you. By the end of that summer I finished my first mature novel, and was taken on by my agent. By fall I would begin a new book that would change my life, and the direction of my work, opening the door to other works that, prior to this time, I'd never had sufficient vision or experience to write.

I finished the new novel the following spring, and was fully aware that I had crossed a major threshold. My agent, who I was still with at the time, went nuts over it; so did every critic he showed it to. Everyone agreed that the book was timeless, that it had dramatic depth, and that it would likely adapt into a powerful film. My agent was certain that my day had arrived.

The book was rejected thirty-six times before he finally gave up on it. The rejections more or less tended to read as follows:

> "... am returning Paul Dorrell's COOL NATION with deepest regret. I read every word with interest, and was genuinely moved by the book's breadth and candor, but am frankly uncertain as to how to market this novel in the current publishing climate ..."

And so on.

Editor after editor told us they wanted to publish the book, but were reluctant to because they didn't know how to sell it. So they stuck with safe bets like Danielle Steele,

whose path was paved by Jacqualine Suzanne, whose path was paved by Hollywood, the grand capital of safe bets. For the most part that's what we've become in the arts: a nation of safe, and shallow, bets.

Manhattan is supposed to be the center of the free world now—the center of the arts, democracy and innovation. But sometimes, in its neurotic frenzy, New York fails to see beyond the Hudson, or forgets to, or believes that it doesn't need to. Unfortunately that elitist attitude locks out about ninety percent of the country. I was writing for the country as a whole, not just New York, and it galled me to no end that I had to submit my work through such a narrow, and sometimes unenlightened, channel in order to reach a broader audience. I knew my subject better than the majority of New York publishers did—in fact I knew the country better than most of them. But until I convinced them of this, they would go on holding me back.

I took the rejections well for a while. Then they started to get to me. Then in a rage one night—again out of money, out of hope, worried sick for my family's future—I went nuts and slugged a few holes in our bedroom walls. The next day my wife talked some sense into me, sent me off to work, and covered the holes with photos of our children. I still haven't patched those holes. In fact I like keeping them there, as a reminder of who I am and where the passion comes from.

That was several years ago. I'm done with the rage now. I'm also more understanding of New York publishers— who have to turn a profit just as galleries do, have to make tough choices in the process, and even then realize profits that are surprisingly small.

Not long after that series of rejections, as well the rejections of my next two books, I left my agent, deciding I was better off on my own. He had been very kind to me, and wonderful to work with, but for the time I was done with

New York. I realized I no longer needed them, and that in fact they'd begun to impede me. I struck out on my own, which I've been doing all my life, and with which I am infinitely comfortable. Making that decision, after I've reached the frustration point with people of "influence," always comes as a relief: it reinforces my sense of inner power, self-determination, and dignity.

No sooner had I decided this than I realized that eventually all of my better works would get published, and that it was just a matter of waiting for the right time—even if, as in the case of many artists, that didn't come until after I was dead. My job was to live more for the work than the deal, while still allowing the deal to form. My job was to never give up, to never cease pulling vision out of nothing and inspiration out of my guts, no matter how long the wait. It's a good thing I didn't know in the beginning just how long the wait would be though; I'm not sure I could have made it this far if I had.

In the end I gained resilience from the wait, knowing that the longer it was, the better my work became, the better prepared I would be. But I only gained that resilience by learning how to deal with adversity, how to take lessons from it, and how to allow it to improve my writing.

So sure, I understand frustration, I understand the anguish of being rejected, and I certainly understand what it's like to keep the vision against all odds. You will likely, at some point, have to come to terms with this also. It's either that or let it destroy you. Well I don't know about you, but I'll never let anything or anyone destroy what I was born to do. Ultimately the only person who has the power to do that to me, is me.

### Going On

The disaster of my finances not only stoked my writing, but it stoked my work as an art dealer as well. Soon after moving the gallery, I began pursuing large sculpture

commissions that, three years earlier, I wouldn't have had the confidence to pursue. The most massive of these was the National D-Day Memorial in Virginia.

The plans called for nine bronze figures of monumental size. I told the committee of businessmen and retired brass that Jim Brothers would execute this commission as no one else would, but only with the understanding that we were not going to glorify war. In this post–Vietnam era, that is something I refuse to do. I told them we were going to make the works disturbing, moving, and in some cases emotionally difficult to view. To my surprise, they all agreed that that's how it should be done.

As it turned out, Steven Spielberg was working toward the same end with his movie *Saving Private Ryan,* which came out when we were halfway through the project. Eventually he became involved in the memorial, and acquired one of our maquettes.

Four years after signing the D-Day contract—years that were filled with long hours for me, and insanely long hours for Jim—I had the pleasure of watching him, on dedication day, sit on the speakers' platform with the president of the United States. In other words, a mere eight years after Jim and I discussed my opening a gallery, the president was dedicating one of our projects. CNN, *The New York Times, The Washington Post,* National Public Radio. . . we had more press than we knew what to do with. I knew now that Jim's career was virtually assured, and that we had begun to reap the rewards of all our years of sacrifice.

As I sat at the front of that crowd of 20,000 and listened to the speeches, looking out over those all scarred veterans, I felt a sense of satisfaction like none I'd ever known. The relative prosperity, of course, was the least important part; it was the satisfaction that mattered. I certainly didn't mind having a little money, but already I knew that my lifestyle wouldn't change. It was enough to finally just have a sav-

ings account, and to be able to open college accounts for my children. Jim felt the same way. We both knew we had been very fortunate.

The D-Day contract wiped out half my business debt, but not before that debt had reached $100,000. The contract did not, however, change my business overnight, make us suddenly successful, or magically open doors that had previously been closed. All it did was lend us a national credibility that, in figurative bronze, we had previously lacked. Utilizing that accomplishment, and several others, I set about the task of taking my gallery to the next level. This involved incorporating the business, bringing aboard a group of well-connected partners, stepping up the marketing, and pursuing new commissions with greater vigor. That endless process is what eventually wiped out my debt, and put us in the black. But none of it was automatic, just as our future success is not assured—except by stint of the everyday work I invest in the gallery, my artists, and my books.

Within six years of opening my new space, I had a website, competent assistants, a steady flow of commissions, and a growing list of clients. My artists had never felt more gratified, I had never been more sure of myself, and never felt so much like I had nothing left to prove. I'd long ago tired of proving things. Now all I wanted to do was achieve new goals, write new books, and start giving back to the society that had made my success possible. I began that process by participating in programs that were designed to reach out to artistically talented kids who had never had many opportunities, or breaks. After all, one of the conditions of participating in a democratic society is giving back to it. I'd like to believe that that condition of giving— which only facilitates the receiving—will go on for the rest of my life.

I have a feeling it will.

Why have I told you this long, complex, rather personal story? To assure you that you're not alone in facing your adversities, and despairing at the odds. Forget the odds. Achieve the work, and the accompanying goals, no matter what roadblocks may arise. Become a master at avoiding those roadblocks, or driving through them, or better yet, trying to understand why they're there in the first place. You can accomplish, in your own way, what we have, provided you're determined enough, disciplined enough, and maybe a little bit naive. Sure, you can be cynical about it as well, but you'll likely find that that attitude will, in the long run, be of far greater cost than benefit.

When I started this whole ridiculous process, I had trouble envisioning anyone less suited to running a gallery, and writing worthwhile books, than I. I felt so inept, so incapable, so much the perpetual loser. What I didn't know was that I was winning experience, and knowledge, all the time. It helped that I tried to keep an open mind, and that I tried to learn from every mishap. It also helped that I refused to let booze overwhelm me, or bitterness dictate my outlook, or self-pity my end. But countless other things helped as well—primary among them my boneheaded Midwestern stubbornness, and my absolute refusal to give up.

Was it all worth the price? That's the odd thing: there was no price, only gain—the least significant of it monetary. Would I do it all over again? If I had to, but I hope I never have to.

⬥ "Westward," Stainless Steel, 11 x 3 x 3.5 ft., Private Collection, Miami, FL, by Arlie Regier.

# OVERLAND PARK CONVENTION CENTER

▲ "Growth," Blown and Cast Glass, 37 x 3.5 x 3.5 ft., by Vernon Brejcha, with Dierk Van Keppel.

◀ "Hoodoo Rain Doll," Oil on Canvas, 24 x 30 in., by Mike Allen; "Lipstick," Ceramic, 34 x 10 x 10 in., by Miguel Rodriguez.

▼ "After the Fire," Acrylic and Ink on Canvas, 30 x 40 in., by Patricia Duncan.

**OVERLAND PARK, KS**

# OVERLAND PARK CONVENTION CENTER

⬤ (Left) "Lyric," Black Slate, 60 x 18 x 10 in., by Mack Winholtz.
(Right) "Belle Reve," Acrylic on Panel, 40 x 30 in., by Tyler Lyke.

⬤ "Origins," Fabric, Stitching, Glass, 38 x 62 in., by Phil Jones.

**OVERLAND PARK, KS**

▲ "Lantern," Acrylic and Fluorescent Light, 17 x 17 x 14 in., Private collection, Austin, TX, by Erin Holliday.

◀ "Crimson Trees," Pastel, 12 x 12 in., Private collection, Santa Fe, NM, by Kim Casebeer.

▼ "Two Bridges," Oil on Canvas, 36 x 48 in., Lockton Companies, Kansas City, MO, by Brent Watkinson.

"Lightning Strike," Acrylic on Canvas, 9 x 4.5 ft., Sheraton Hotels, Overland Park, KS, by Phil Epp.

# NATIONAL D-DAY MEMORIAL

▲ (Foreground) "Death on Shore," Bronze, 1.25x Lifesize, by Jim Brothers.
(Background) "Through the Surf," Bronze, 1.25x Lifesize, by Jim Brothers.

▶ Detail from "Death on Shore."

▼ View of Site.

BEDFORD, VA

# NATIONAL D-DAY MEMORIAL

◀ "Scaling the Heights," Bronze, 1.25x Lifesize, by Jim Brothers.

▼ Jim Brothers, in studio.

**BEDFORD, VA**

▲ "Field Flow," Blown Glass, 3.5 x 20 ft., The University of Kansas Hospital, Kansas City, KS, by Vernon Brejcha.

▼ Detail.

▶ Vernon Brejcha, in studio.

# UNIVERSITY OF KANSAS

KANSAS CITY, KS

 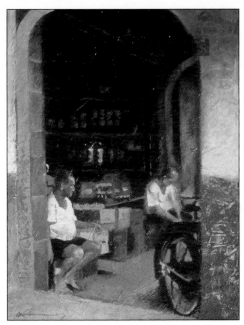

▲ "Canyon Piece," Stoneware with Running Water, 7.5 x 4 x 5 ft., Corporate collection, Beverly Hills, CA, by Wolfgang Vaatz.

◆ "Kedai Runcit," Oil on Canvas, 18 x 14 in., Private collection, Fairway, KS, by Allan Chow.

▼ "Thunder Head," Oil on Canvas, 30 x 40 in., Hunkeler Eye Institute, Kansas City, MO, by Phil Starke.

△ "Stone Fencepost," Oil on Canvas, 30 x 40 in., Private collection, Naples, FL, by Louis Copt.

▽ "Hemisphere in Steel," Stainless Steel, 6 x 17 x 17 in., Private collection, London, England, by Arlie Regier.

# R.R. OSBORNE MEMORIAL PLAZA

▲ "Reflective Spaces," Ceramic Tile, 15 x 32 ft., by Phil Epp and Terry Corbett.

◣ View of Site.

▶ "Giving More Than You Take," Stainless Steel, 15 x 6 x 4 ft., by Arlie and Dave Regier.

▶ (Opposite) Arlie Regier, in studio.

**OLATHE, KS**

# R.R. OSBORNE MEMORIAL PLAZA

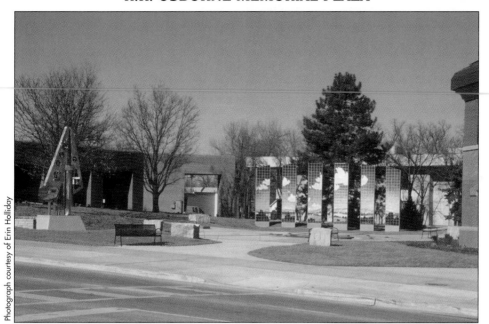

Photograph courtesy of Erin Holliday

OLATHE, KS

⬆ "Countryside," Organic Earthworks, 200 x 200 ft. (1 acre), Upper West Side, Manhattan, NY, by Stan Herd.

⬇ "Prairiehenge," Limestone Columns, 15 x 100 x 175 ft., Collection of Bill Kurtis, Red Buffalo Ranch, Sedan, KS, by Stan Herd.

▲ "Tribute to Wright," Rare Woods, Stainless Steel, 53 x 48 in., Private collection, Kansas City, MO, by Matt Kirby.

▼ "The Caged Bird Sings," Oil on Museum Board, 13 x 20 in., Private collection, Kansas City, MO, by Richard Raney.

▲ "Mark Twain," Bronze, Lifesize, Hartford, CT, by Jim Brothers.

# SEVEN

## *Getting Into the Galleries*

All right. Let's assume that you're now ready to approach a legitimate gallery. You've exhibited in juried shows, you've exhibited in restaurants and offices, you've found your audience, and are confident of your work. With these things behind you, you're ready for me to begin walking you through the process of approaching galleries. I'll go about this so that you learn to do it right, do it with resolve, and do it well. This doesn't mean that my approach is the only one, but it is one that works.

So, with a resume in hand, let's proceed.

## *Rejection & Perseverance*

Before we do go on to the galleries, it's best if you acknowledge that your work will probably be rejected several times initially, and that finding the right gallery will likely be no simple task. Therefore, let me give you one piece of advice about rejection: get used to it. Let me also give you another: determine to persevere, no matter what.

Perseverance is the quality that enables you to handle rejection after rejection, then more rejection, then further rejection, then perhaps a few more years of rejection after that, and still snap back. I'm not saying that those rejections shouldn't depress or anger you, or at times make you want

to abandon the whole bloody business. They should, and will. But you'll have to persevere nonetheless—that is, if you want to succeed.

*You're* the one creating the work. *You're* the one who has to believe in yourself. *You're* the one who has to know whether your work is any good. If you do know this, and are certain of your artistic destiny, then no amount of being turned away should make any difference. Sure, you may punch a few holes in some walls before it's over, but after the dust has settled, and you've mended your knuckles, go back out and make the approach again. And again and again. And again.

Don't get desperate. Don't give in to despair. Listen to your inner voice, the one that has assured you about your work, and your place in the world, since the day you first began to create. Voices like that rarely lie (which isn't to say that we don't on occasion misinterpret them). Listen to the reassurance it gives you, assuming it does.

As you listen, and as you prepare to send your work out once more, try to employ resiliency, combined with stubbornness, mellowed with humor, strengthened with discipline, bound with humility. And hell, enjoy yourself while you're at it. You're alive, you're free to create, your work is maturing. If you learn to take the rejections well, you'll gain strength and character from them. In time, this can lead to one formidable artist, and career. Decide that it will, and that the day is coming when the galleries will be happy to work with you. People respond well to confidence—which should never be confused with arrogance.

Determine that the rejections will help build these things up in you; they can, if you decide to take them that way. They can also destroy you, if you let them. Don't. In the end, the only person who truly has the power to destroy you, is you. That's a tough one to remember, and a tougher

one to practice, but from everything I've seen in the world, I believe it to be essentially true.

Now, let's get on to the galleries.

### Choosing the Right Gallery

In the beginning, I advise that you start with galleries that are located in a major city or resort near you. Visit them and browse. Don't mention you're an artist, don't mention anything. Just walk around and get a feel for the place. Will your work fit in with the collection? Is the gallery well laid out and well-lighted, or is it dim, dusty and reeking of disorganization? Does the place exude contentment and confidence, or despair and ineptitude? Most importantly, are the director and staff snobs, or are they considerate and helpful? If the former, I advise you stay away.

Snobbishness, like so many negative traits, is rooted in insecurity. If the director is this way with you, chances are he's this way with clients, which will only lead to lost sales and commissions. I have to admit though, some snobs do make excellent art dealers, they're just a pain in the ass to work with. In the end it's a personal call. If you feel you can work well with one of these folks, go ahead—just watch your step as you proceed: snobbishness, by my experience, is often an indicator of a lack of integrity, not to mention a lack of enlightenment.

After you've sampled enough galleries to know which you want to approach, drop by and make an appointment to see the director—portfolio in hand. Why do you do this in person? Because requesting an appointment in person normally works better than making a call, since it's harder for someone to refuse you if you're standing in front of them.

If the staff member tells you the director is not looking for new artists, talk the staff member into looking at your work anyway. No, don't hand him a satchel of paintings,

hand him the portfolio—with one of your originals nearby in case it's needed. If you're already talking to the director, so much the better. If not, and if the staff member is impressed, try to make the appointment. If one can't be made at that moment, take a business card and call later, persisting until the director either agrees to see you, or gives you an unequivocal *no*.

If the only way the gallery will view your work is by your mailing them visuals, fine. Type a <u>brief</u> cover letter on quality stationery, enclose the slides and prints, your resume, at least one postcard (remember those?), and a self-addressed, stamped envelope. Also include any press clippings that you may have managed to garner. Give the recipient seven days, then call and ask if they've had time to look everything over. If they have, try to get an appointment to go in and show your work.

The first gallery won't see you? Try a second, then a third and fourth if necessary. No matter how many rejections you get, you must persist. As I've already pointed out, if you've got the talent, and have paid the dues, you will find the right gallery—but only if you're persistent enough; if you're not, you won't.

When you do get your appointment, arrive on time, be brief, be confident, and reflect certainty in your work. Take at least three of your best originals with you. Dress any way you want, just don't go in looking like you're desperate and starving. You want to go in looking like a success, even if that success is only expressed in the mastery of your medium. Make sure your presentation is neat, organized and professional—with quality frames on your paintings if frames are needed, or refined bases (marble, granite, finished wood) on your sculpture if bases are needed.

In my gallery, when an artist walks in the door for an appointment, he'd better be prepared or I'll lose interest fast. Sure I'm primarily looking at the work, but I'm also

looking at the artist, and gauging whether he'll be responsible in his obligations. If I see real possibility in the work, I'll help him organize his career, but only if I sense that he'll carry his weight. If he strikes me as being unreliable and undisciplined, I'll politely show him the door—no matter how brilliant the work might be. Headaches like that I just don't need.

Equally important is the manner in which the dealer treats you. Does he treat you with respect? Is he considerate? He may be busy. He may be in debt up to his hindquarters. He may be having one awful day. Even so, you deserve respect for the years of sacrifice you've paid out in mastering whatever it is you do. Bear that sacrifice in mind, and be proud of the accomplishment it reflects. Pride, when wielded wisely, will carry you a long way.

You must also be the same way with the director—starting by making the appointment first, and not by just showing up and expecting him to drop everything for you. Most directors are very busy, operating their gallery on a thin profit margin, assuming they're making a profit at all. It's difficult, vexing work to run a gallery. Just be glad you don't have to do it. All you have to do is paint, or sculpt, or whatever. But the gallery, if they take you on, has to convince the public that you're worth investing in—no mean feat. That's why when you meet the director, it's important that you're aware of the reality he grapples with every day.

What I mean is, when that first meeting occurs, it is critical that you show some form of respect, and that it be returned. Later a deeper sort of respect will have to be earned, and it will have to be mutual. You both will need to achieve this if you're to have a good working relationship; if you don't, you won't. As you're talking with the director, keep this in mind. This two-way street will be one of the most important you'll travel in your career. It involves all the give-and-take of any successful relationship.

## *Coming to an Agreement / Gallery Percentages*

This should be a straightforward, no-nonsense aspect of the arrangement. Normally it works like this:

The director agrees to take your work. You consign perhaps six pieces to him. You deliver the work, and he prints out and signs a consignment sheet for you. My consignment sheets generally read as follows:

To Whom it May Concern:

This is to confirm that Donna Quackenbush, artist, has consigned to _____ Gallery the following oil paintings:

"Sur Le Pont," Oil on Canvas, 36 x 48, $3,000

"Ornamental Wind," Oil on Canvas, 36 x 44, $2,700

"Remain in Light," Oil on Canvas, 28 x 36, $2,300

"Petra," Oil on Canvas, 28 x 36, $2,300

These paintings are consigned for a minimum of 12 weeks from the above date. The paintings listed will be insured for their appraised worth against loss or damage for any reason whatever by _____ Gallery during the period of exhibition. _____ Gallery is to receive a commission of 50% of gross on any sales that are made during the exhibition, or as a result of exposure that Donna Quackenbush received therefrom, or from any insurance claim.

Artist will be paid within 30 days of each sale, or any insurance claims.

With sufficiency acknowledged, I sign my name in good faith.

Donna Quackenbush
Artist

Paul Dorrell
Director

*Figure 3. Sample artist/gallery agreement*

Note that the sheet lists the title, medium size and price of each work. It also lists the commission charged, and the fact that insuring the pieces is my responsibility. This should always be the gallery's responsibility, even for fools who are so broke that they allow their insurance to lapse.

At the time of this writing, I charge varying commissions on works in varying media. These are as listed below.

> Paintings...............................50%
> Blown Glass .........................40%
> Steel Sculpture .....................40%
> Ceramic Sculpture...............40%
> Bronze Sculpture .................33%

In most galleries, you'll find it is standard to charge painters a 50% commission. If the prices on the works are high enough, both you and the gallery will make a sufficient profit. If your frames are inordinately expensive, perhaps the gallery will split the cost of these with you, but don't count on it. Galleries have enough overhead as it is; better to simply figure the cost of the frame into the price of the painting, and make your profit after.

Why do I charge only 40% for steel, glass and ceramic sculpture? Because expenses for these artists are far greater than for painters; I personally feel it would be unfair to charge them the same commission. Some galleries agree with this, some do not. Many charge a straight 50% to all their artists, regardless of medium or studio expenses. I wish I could do this, but in good conscience cannot. On the other hand, my overhead is nothing compared to that of galleries in Santa Fe or New York, so I can understand the policies of those in the more expensive meccas.

My reasons for charging a 33% commission on bronzes are, again, based on the artist's expenses, since expenses

are extremely high for bronze sculptors, primarily due to the cost of casting. I can't ignore this condition, and so simply decided to work with it. Therefore, the formula we employ in determining the retail price of a bronze is simply to multiply casting fees by three. Thus if a bronze costs $1,000 to cast, I sell it for $3,000, plus $200 for the marble base, bringing the total to $3,200. After selling the piece I retain $1,000, and the artist gets $2,200, $1,200 of which will go into casting and basing the next piece.

The percentages work differently with commissioned, one-of-a-kind pieces, which I will discuss in Chapter Eight in the section titled, surprise, "Commissions." For now, let's just stick to standard gallery business.

### You're In a Gallery. Now What?

Firstly, don't expect miracles. Give the dealer time to work the market, and to find out which of your styles sells best. If he makes suggestions regarding your work, and how to make it more salable, listen to him—unless he's a qualified idiot, in which case you shouldn't be with him anyway. Learn humility if you haven't already. If he's urging a subtle change or a possible new direction, play with it, see if it works. You do not have all the answers where your work is concerned. Neither does he. Neither do I. But I do find that when I work with an artist open-mindedly, and when that artist works in the same way with me, the results are always good.

This does not mean, however, that the more shallow aspects of the art market should dictate how you work. If you allow that to happen, you'll wind up creating work that lacks soul, integrity and passion. *Always* stay true to your vision, and always work within the guiding parameters of your intuition. If you let other people sway you too far with well intentioned suggestions, you'll get off the path of your own instincts. In the end, only you can know

what it is you want, or need, to create. No one else can fulfill this role for you, and no one else should.

## Passion

By this I don't mean yours, but the gallery's for your work. Maybe they'll call it enthusiasm, or appreciation, or sheer love. However it's termed, the gallery staff should *feel* a genuine fascination for what you do. Why? Because collectors will sense their passion, and will in turn become infected with it. This will lead to sales, and to a broadening reputation.

Adversely, if the gallery staff are indifferent to your work or, worse, blasé, this too will be sensed by potential collectors. The next thing you know, you'll become one of those non-selling artists whose pieces are ignored, then begin collecting dust, then are dumped on the storage shelves in the basement.

There is also the possibility that, no matter how impassioned the staff are, and no matter how hard they work, your stuff simply won't sell. It could be you're in the wrong gallery, the wrong region, or it could be that no one has an answer for this unfortunate, but all too common, failing. Nobody can really predict the art market, just as no one can really predict that other market based at the corner of Wall and New Streets. Even so, the combination of a gallery's energy, and your mastery, will normally bring good results. Try to ensure that each gallery you work with functions on this basis. If, after all good efforts, the work still isn't selling, always be willing to try another gallery.

## Exclusivity

Any viable gallery that consents to represent you should be given exclusive representation of your work in their area. If you live in their area, this applies to your dealings as well, which means no selling out of the studio. Does this seem unfair? It's not. In the long run, you'll benefit far

more by having a competent dealer handle your sales, and promotion of your work, than by trying to handle these things yourself.

If no galleries in your area represent you, you can continue selling out of your studio, assuming that you are doing so already. Some artists, albeit very few of them, are adept at this. In general though, I find that artists don't want to be bothered with this aspect of their careers. It tends to go against the grain of creation, and tends to call on a different set of talents. Most artists recognize this, and choose to avoid the whole business. As a rule, I find this is wise.

### Getting Paid

Let's be optimistic. Let's assume the gallery's going to sell a truckload of your work. As they do, you will require payment. This shouldn't be a problem, but sometimes it is. It's best then to discuss the payment process with your dealer in advance, so you'll know what to expect, and what to watch out for.

Anytime a piece sells, you should be informed of the fact within roughly two weeks of the sale having taken place. A check should be forthcoming within thirty days of the sale. If a gallery *ever* takes longer than thirty days to pay you, something is wrong. Either there's a problem with the bookkeeping, or they're broke, or dishonest.

Whatever the problem is, get to the bottom of it. Make the necessary inquiries, be polite but firm, and find out just when you will get paid. Try not to lose your cool. If the gallery is run by an honest, hardworking director, you'll want to stay on good terms with him. He may be experiencing a condition of temporary impoverishment, but he may wind up working wonders for your career later. If you trust him, let him take the necessary time to pay you. This patience may well benefit you both in the end.

Example: In my gallery's second year, my debts, as you know, overwhelmed me. I had to make the unpleasant choice of either paying my artists on time, or paying my bills and staying open. I chose the latter, then informed my artists of the decision. All of them were upset, all of them understood, but mainly they were upset. Still they knew that without my efforts, they would likely remain obscure Midwestern artists. None of them wanted that, and none of them wanted to see me close. We all knew we were onto something, and that we'd have to stick together to see it through. So we formulated a payment plan, wherein I paid everyone off within six months. I stayed in business, everyone's career benefited, and things wound up well as a result. None of this would have happened if we hadn't trusted each other.

Different example: One of my painters was once represented by some fast-talking, money-worshipping, fashion-obsessed dealer in Aspen. This guy and his wife were like bad actors in a bad movie: they drove Land Rovers they couldn't afford, lived in a house they couldn't afford, wore sunglasses all the time, and were forever on their cell phones "making deals." The gallery had been open a year when the artist placed work with them; it closed six months later. The artist was never notified that the gallery had closed, never paid for any of the paintings that sold, and never got back the remaining paintings. Of course this artist had had a bad feeling about the dealer from the beginning, but he was so excited to be in an Aspen gallery that he overruled his instincts.

If you don't trust a gallery you're in, if they've owed you money for more than a month, and if the director seems so twisted that he'd defecate a corkscrew upon eating a nail, then you'd better pull your work and cut your losses. You can take legal action after the fact—although the only person likely to benefit from that will be the lawyer. Normally

it's sufficient to just harass the dealer until he pays, convincing a local journalist to write a story about it if he doesn't. In fact the mere threat of such a story will often bring results.

By far the best thing, though, is to avoid this conflict altogether. The best way to do that is to make preliminary inquiries about the gallery before you sign with them. Ask for the names and phone numbers of their leading artists. Any well-run gallery will gladly supply this information, and urge you to get the endorsements of their artists. If they don't, then don't sign.

Just as importantly, get a sense of the owner. Is he obsessed with money and appearances? Does he reek of insincerity? Is greed one of the major drives in his life? Does he place a greater value on money than on relationships, and does he have beady little eyes? If these things hold true, then likely the dealer has an integrity problem. There is nothing wrong with being focused on making a profit—lord knows I am—but the art, and the people you work with, *must* come first. If these things are taken care of, along with marketing and sales, profit will follow.

In the end, you must listen to your instincts regarding the galleries you work with. If those instincts are screaming *no no no*, then it would likely be wise for you to listen. If they're telling you *yes*, then listen to that as well.

### Your First One-Woman or One-Man Show

This is a big event for you, and should be treated as such. You've waited years, maybe decades, for this night. Don't overrate its significance, or your own, but do rate highly what it means to you, your career, and your sense of self-worth.

Preparing for the show is the gallery's job; preparing the inventory is yours. The manner in which you split expenses, or don't, can work in any number of ways. In my gallery, my artists and I usually split advertising expenses,

but I pay for the catering, the printing of the invitations, and the mailing of the same. I *always* pay for the catering, since I consider the event a celebration of the artist's talents, and I wouldn't want anybody paying for the grub at their own celebration.

I do not, however, cater my openings lavishly. I used to, when I felt I had to impress my clients with smoked salmon and fine wines. Then I realized everyone was doing more drinking and eating than looking and buying. Too much drinking in fact: once I had to eject a drunk for feeling up the women. After that I changed my approach, ordering only enough hors d'oeuvres and wine to cover the first forty guests. In that way everyone indulged less, and the focus swung back toward the art.

The trick of getting collectors into the gallery is usually achieved through a combination of mailing impressive postcards, and running impressive ads.

When mailed by themselves, postcards can bring a good turnout, but to my select clients I always send a letter as well. The letter will discuss who the artist is, why I value his or her work, their accomplishments, etc. These I usually mail three weeks before the opening, since if they're mailed too soon, people tend to forget about the event, and if mailed too late—well, it's too late.

I always order a thousand more cards than I'll need. In this way, I'll have an abundance to hand out to new clients for the next year—essential in the art business.

Advertisements are a much more costly undertaking, but if I believe in the artist I'm promoting, the ads will prove worth the investment. While I may run some small ads in local magazines, it's the national publications I run the largest ads in, since it's the national market I'm always after. These ads place the artist's work before hundreds of thousands of collectors, and increase the likelihood that I'll sell the piece advertised. The ads also get the attention of

various editors and critics, and begin paving the way for future articles.

Before the ad runs, I always order several dozen issues of the magazine, and a thousand copies of the ad itself—called reprints. Most magazines will supply these for a reasonable fee. Then, as with the postcards, I can hand out the ad for the next year or so. This communicates to clients that the artist's work appeared in a national magazine. Never mind that the image appeared by means of a paid advertisement, what the client will remember is *where* it appeared. This will automatically make the artist seem of higher rank, and will be beneficial to the gallery at the same time.

Does all this seem like a game? It should. Like most things in life, it is. You can either fight it, and get angry about it, and achieve nothing but frustration; or you can accept it, adapt it to your own rules, have a little fun with it, and prosper along the way. I've tried both approaches, and long ago decided which of the two I prefer.

Rodin, who did more than his share of suffering, eventually learned this. So did Magritte, Ansel Adams, and the people who promoted van Gogh's work after his death. It's a pity they couldn't have done the same for van Gogh while he was alive, but let's face it, the public wasn't any more ready for van Gogh's work when he was living than he was for the public.

It seems to have been van Gogh's fate to suffer in obscurity, the harshness of which compounded his instability, affected his art, and finally effected his end—when he shot himself in that field outside Auvers-sur-Oise, stumbled back to Dr. Gachet's house, and died in a little room two days later—broken, mad and alone except for his brother's love. What a tortured existence.

My point? None of you has to endure such absolute obscurity like van Gogh anymore. Oh you still have to suffer, we all have to suffer, but not necessarily like *that*. Art collecting,

in the history of the world, has never been more common than it is now. The world has never been smaller, communication more complete, the possibility for sales greater. You can benefit from that, if you choose to. This doesn't mean that finding your niche will be easy, but I can assure you, it will be far easier for you than it was for the many generations of artists who came before us, and certainly easier than it was for that troubled soul from Groot-Zundert.

## The Critics

Sooner or later, as you do a series of shows, an art critic is bound to cover one of them. As with literary critics, theater critics, and every other kind of critic, you will probably agree with almost nothing they say, and will wind up wondering if they understand your work at all. Some will understand, some won't. You may be flattered by what they write, you may be offended, you may be perplexed, but somehow their interpretation of what you do, and your vision of it, will almost never mesh. Don't worry, it doesn't need to. The critics are just trying to do their job from their perspective, and keep discussion of the arts alive. The fact that they covered your opening is what counts. Most collectors will forget what was written about it, good or bad, and go on and decide for themselves anyway.

I've encountered many fair-minded critics over the years who understood how to write an informed article, and to intelligently give their views. I've also encountered many who seem to be composed only of vitriol and pettiness. These critics often have very definite prejudices about what they consider art—meaning that everything that doesn't fit within the confines of those prejudices, be it toward contemporary or traditional, is disregarded or panned. This attitude often makes me wonder how complete the educations of these people are, and whether concepts of open-mindedness are altogether alien to them.

Just because an artist paints in the manner of Turner, and does it well, doesn't make him shallow because Turner did it so long ago. Similarly, just because an artist creates an installation out of crushed beer cans doesn't mean he is without talent because of the lack of craft. (Installations out of excrement and vomit? I'm intrigued by them, but it's unlikely I'll ever carry them. Anyway one of the Dadaists, Leonor Fini, did all that in the 1920s—with predictable results.) Still I encounter this narrow attitude constantly, and am always disappointed by the bigotry it reflects.

You'll encounter this narrowness in certain critics too. Ignore it. In the long run, the critics will never have as much impact on your career as you, your galleries and collectors will. Critics can exert tremendous influence, but it's a toss of the coin as to how substantial that influence will ultimately be. I advise you to not count on it one way or the other. Learn to count on yourself. There's greater satisfaction in that, and far greater worth.

### Press—Again

Most galleries, I find, really don't pursue the business of getting press for their artists, so it likely isn't fair of you to expect this of them. But if a gallery can do this for you, they should. It is up to you and them, however, to decide what constitutes a good story before approaching a reporter. If you feel you're working on a project that lends itself to coverage, then go ahead and send out the press releases. Naturally the release will look better if it comes from the gallery than from you, but if the gallery is reluctant to send it out, send it yourself.

In the case of my gallery, we seem to land a never-ending string of stories, but that's primarily because I've developed the knack for landing commissions: monuments, murals, civic projects involving multiple works, corporate installations, etc. Most of these have made for compelling

stories, some of them have made for rather dull stories, but they've all made stories nonetheless.

Even if an event doesn't seem major, but involves an angle of human-interest, I'll approach a reporter. Your dealer should try to do the same for you. Encourage him in this, and work with him in any way you can. Hopefully you'll both develop good working relationships with a core group of journalists who will look to you, from time to time, for solid stories of intelligence, passion and risk. These *are* good stories. Try to see them into print.

### Galleries in Other Cities

Since your first gallery will likely be in your own region, it's important that you next establish yourself with galleries in other regions. Galleries are almost always on the lookout for unique talent, regardless of whether they're in a major city, a mid-sized city, or a tourist mecca. Getting to work with galleries in other regions is not that difficult to do, but it will require time, travel, and a little research.

Because my artists and I have always been based in the Midwest, I long ago decided that if we were to succeed on a national level, it was essential that I get them accepted by major galleries elsewhere. Those other galleries had more influence than I did at the time, and I wanted to capitalize on that influence, reasoning that if one of my artists did well in Chicago or San Francisco, he would experience increased sales and stature at home. The reasoning proved correct.

Before beginning my search, I gathered gallery guides of the various cities I was interested in. Gallery guides can be obtained through chambers of commerce, gallery associations and individual galleries. If no guide is available for the city you're considering, go to the library and make a copy of the gallery section of the Yellow Pages. This will do well enough.

Using one of these references, make a list of the galleries that you think would be appropriate for your work. View their website, and get a feel for the sort of work they carry. Then call and ask questions about the gallery itself, or have the director of the gallery you're already in do the same. Ask about their price levels, how long they've been established, and in general get a feel for their approach to business. If they sound like snobs, don't worry, a lot of gallery folk sound like snobs on the phone. Most of them don't mean to, it's just that they're weary of being approached by unprepared artists. Prove to them that you're prepared, and professional, and that snobbish veil will often lift.

Once you've compiled your list of galleries, you'll likely hope that you'll be able to achieve acceptance via e-mail and the phone. In most cases this simply won't work. Instead, you'll probably have to go to the chosen city and investigate. Make it part of a vacation, make it a business trip and write it off, or just make it a very low-budget journey. However you do it, I feel you're best off if you travel there in person. There really is no other way to assess the galleries of interest.

Take plenty of slides and prints with you, take your portfolio, and also take sufficient inventory, since your goal is to place work while you're there.

Once you've arrived in the city and have found the galleries, follow the same sequence of steps for approaching them that I laid out earlier in this chapter. Employ a variation on the steps if you want, invent your own steps if you prefer, but thoroughly look into all the galleries before deciding which ones you want to deal with.

Since you're only going to be in town for a brief while, it is essential that you get a staff member to view your originals. Normally a major gallery will only do this through your making an appointment. But on occasion, if they like the portfolio well enough, they'll ask to view the work as

well. However you do it, you must show your originals to a handful of galleries before you leave. They may love your work, they may detest it, they may be indifferent to it, but you must try to achieve this.

Even if you do achieve it, it is highly likely that no one will accept your work this first time out. Nonetheless, try to establish a relaxed rapport with whatever staff member you might meet. If they respond favorably, but tell you that they won't be looking for new work until next year, fine: go home and send them occasional updates on your career until the next year. At that time, try to make another appointment, and start the process all over again. In other words, be persistent. (Have I mentioned that before?)

Also, be sure to have the director of a gallery in which you're already established contact the staff member. Have that director assure this person of the salability of your work, of your professionalism, your dedication. If necessary, have him assure them of your charm and effervescence—whatever it takes to place the work.

Certain galleries will refuse to make an appointment with you, and will only view your work on the basis of a mailed submission. It's best to anticipate this, because it will occur. When it does, get the card of the person to whom you're supposed to write, and send him a presentation folder that is laid out like a portfolio in miniature. This folder must seem as impressive as your large portfolio, but in an abbreviated sense. As with the portfolio, make these folders a visual feast. No, don't decorate them. Just make them a pleasure to flip through. As always, include a stamped, self-addressed envelope, since you don't want a gallery hanging on to the thing if they're not going to carry you.

I've helped several of my artists get placed in other cities, but only when I felt that other directors would listen more closely to me than they would to the artists themselves. I always told those directors that I didn't want any trans-

actions to go through me, but that I only wanted to introduce them to work that I felt had great potential for them. When it was required, I even traveled to the city in question—Santa Fe, Miami, Carmel—to personally meet with the director and convince him why he should carry this or that artist. Each of my artists was relieved to have me do this, and agreed to pay me 10% of all sales resulting from the new gallery. In most cases the arrangement worked out well, and everyone benefited. In some cases it proved to be a waste of time, but that's one of the risks you must take.

There are numerous ways to go about the business of placing work in other cities. However you do it, it is an essential element in the advancement of your career. As soon as you're established locally then, make it a priority to become established elsewhere. Once this is done, make sure your local gallery announces the fact to their clients, and make sure this change also appears on your resume. I assure you, it will have an impact.

### Your Relationship With Your Dealers

Hopefully, these will be long-lasting alliances built on mutual respect and integrity, resulting in a growing prosperity. You don't need to socialize together, you don't even need to be friends, but you do need to be on friendly terms. If any of these relationships are tense and abrasive, those are the ones that will probably lead to difficulties. If they are for the most part trusting, and based on solid business fundamentals, those will probably lead to higher levels of success. I hope so. You've earned as much; so have your dealers.

# EIGHT

## Clients, Rich and Otherwise

Whether you're representing yourself, or whether a gallery represents you, you will in time be dealing with a variety of clients—assuming that you want to sell your work. As you deal with them, remember this: the wealthy collector, the moderately wealthy collector, and even the not-so-wealthy collector all have one thing in common: they want to connect with your work. The somnolently wealthy you can forget about, since they likely won't come around in this lifetime, nor possibly even the next.

But for the ones who are awake, to connect with your art makes them feel more alive, even rebellious, especially after all the years of dull, repetitious, mind-numbing work many of them have had to do in acquiring their wealth. Unfortunately that kind of money-chasing often compromises growth, and can create an imbalance that is reflected by harsh acquisitiveness, appalling selfishness, and virtually no awareness.

When you meet certain of these people, you may see how their dignity suffered as a result of that chase, how all too often their goals were misplaced, weren't sufficiently rewarding, or were assigned undue priority. This may make them depressed, half-alive, or primitive in outlook, consumed by the misery of their greed. All too often this is

the case. Their fixation with money likely screwed up their marriage, their kids, their own lives, leaving them drained of humanity, outside the feast of life, with them now trying, through art, to reach for greater meaning.

Or perhaps they care nothing about a life of meaning, and are simply insatiable consumers who can never have enough *stuff*—paintings and sculpture included.

Or perhaps they're just sophisticated lovers of art, leading lives of consideration and generosity, reaping the rewards of their hard work, and enjoying the life of plenty that can sometimes be achieved in this strange, wonderful, overwrought land.

Whatever their individual natures, the rich do have a place in our system, and while it might not ultimately be as important as many of them think it is, it is still significant. Their businesses help create jobs, many of them passionately support the arts, and, when of the visionary sort, they do things for the underprivileged that you and I can only dream of. Regardless of who they are, and how benevolent they may or may not be, you must not judge them, you should never envy them, and you certainly should never allow yourself to be intimidated by them.

Be cool when dealing with the rich, be confident, but be humble. Like anyone, they are only looking for acceptance. Accept them if they behave themselves. If they do not, if they offer you absurdly low prices for work that you know is fairly priced, quietly decline. They'll respect that, and will probably come back later. But if they become insolent and disrespectful, show them the freaking door. On occasion it feels good to do this to those who so rarely have it done to them. It will be good for you, and possibly later even good for them.

Then there are other clients: teachers, physicians, small businessmen and women, architects, housewives, househusbands, lawyers, bankers, stock brokers, priests, rabbis,

and a whole range of other people who are potentially interested in what you do.

Some of these people may know nothing about art. Good, don't play the snob game with them (not everyone *needs* to be versed in the arts); instead, teach them. As I've already mentioned, anyone can respond to art. It is your job, and your dealer's, to help the less educated of your clients do so. The art world should not be a coded society where only those with the proper enunciation, attire, and hip phrases of the moment are allowed entry. That sort of exclusion only perpetuates the ignorance, when the point should be to eradicate it.

It may be that several of your potential collectors can barely afford art. Fine; allow them to make payments. For some of these people it might be their first acquisition, and the first in a series of steps where they open that window to the soul—the creative one I mean. Art can help them do this, whether they're acquiring or creating it. Congratulate them on having vision.

Still other clients may live lives that are already full and flowing, where their lifestyle is virtually a work of art itself. Maybe they're more alive than even you or I. Wonderful, then buying your work will only complement what is already impassioned.

Treat all of these clients well, regardless of their monetary status. They'll appreciate that, and will express the appreciation by buying more work, and by sending friends and relatives who will do the same. The best of them will share their wealth rather than horde it, and the circle of prosperity that they help perpetuate is one you may well be grateful to be a part of. Some of these people, the rich included, can be incredibly open and generous; allow them to be, allow them to help you, since you'll never achieve all of your goals on your own.

Finally, when a client buys a piece, it is cause for rejoicing—and I mean for everyone involved. A sale should

*never* be seen as a one-sided victory for the artist or gallery, where perhaps a client was fleeced, paying excessively for a work that will never maintain its supposed value. Unfortunately, I've been in many galleries who deal in just this way. People who view each success in one-sided terms tend to lead unbalanced, one-sided lives. I advise you to avoid this, and avoid galleries that function under this narrow view. You'll only find misery with that attitude, never contentment. After all, how do you think so many of the rich wound up being so miserable?

### Large Commissions: How Do You Get Them?

Large commissioned works are normally landed through established galleries. But for now let's assume you're not yet in a gallery and are able to land a few commissions on your own. Let's assume you know, or have heard of, a CEO, restaurateur, or politician who is seeking to commission a large painting or sculpture. However you meet these clients, if it's your first major commission, pay attention to what I'm about to cover. It details a set of circumstances that are far more common than not.

In the beginning with commissions, you'll virtually have to give your work away to place it, since until there's a value attached to it, it will be difficult to get corporations and private collectors to pay you what a large work is worth. I'm not saying you *should* give it away. I'm only saying that, until you're established, you'll have to be willing to accept moderate or even meager pay as compensation for what will likely be a lot of backbreaking work. You may even have to be willing to barter for a commission, as many of my artists have, with car dealers, restaurant owners, dentists, etc. But if the space is in a good location, and the client has a passion for what you do, the barter will be worth it.

Example: Jim Brothers' first commission, prior to when he and I began working together, involved a life-size bronze

for the River Market in Kansas City. Jim was so thrilled to be placing a large piece in a public space, that he unintentionally bid the job for just a little over cost. By the time he finished the thousands of hours of sculpting, mold-making, and wax-chasing, he regretted that, but after the dedication he felt better. Anyone would feel better after one of their works had been installed in the midst of a large city. Just as importantly, when he and I began working together a year later, I was able to use that piece to our advantage, showing it to prospective clients and closing deals.

In fact it was primarily due to that installation that I, over time, was able to convince G. E. Aircraft Engines to commission Jim to execute a series of bronzes. This led to other clients, and other commissions, which led Jim to where he is now: stacked up with commissions, and selling out virtually every limited edition bronze he creates. Was that worth the sacrifice of virtually giving away his work in the beginning? You tell me.

However you secure your first commission, I recommend that you draw up a letter of agreement before you proceed with any work, and before any money changes hands. This is essential, as it spells out the terms for everyone, and often prevents misunderstandings from occurring later. The agreement must be signed by both you and the client, with the letter spelling out the terms of the commission. I've provided a very basic sample letter on page 142 (Figure 4), based on one we recently used with a hotel corporation. Use this as a basis for your own letters if you like.

No, a lawyer didn't draw this up; I did. I know it has all kinds of legal loopholes in it, and I don't care. I trust my business sense in landing commissions, negotiating them, and civilly working out the loose ends. Consequently, I rarely involve lawyers in reaching agreements, since that tends to delay matters, drives up costs, and can inspire mistrust. But if I must hire a lawyer, I always resort to one

Date

Name of Corporation
Name of Contact
Address
City, State & Zip

Dear Client:

Enclosed please find the proposal regarding the West Lobby Mural for the such and such hotel. The painting will be executed by Quacken Donaldbush. I've listed below details involved in the commission.

Once this proposal has been approved, we will proceed with Donaldbush executing a study that will be painted to scale (roughly 14" x 20"). After the study has been completed, I will forward an 8" x 10" photo of the work to your offices. This will inform you of how the mural will look, although the study, of course, will not have the depth or drama of the mural.

I've listed below the various details concerned in the commission.

1) **Painting for Main Lobby.**
The painting being commissioned will interpret a rangeland scene of surreal prairie with broad sky and scudding clouds, according to the artist's established style, with an agreed-upon study as specific reference. The dimensions will be 6' x 9' unframed. The painting will be oil on canvas.

**Price:** (Sorry, the hotel would be furious if I divulged this.)

**Lead-time:** Please allow two to three months for execution. We do warrant, however, that the work will be completed no later than three months from the date that we receive the first payment.

**Payments:** The work will be paid for in two installments: one-half to execute studies and begin the painting; the second half upon completion of the work.

**Framing:** The above price does not include framing.
**Installation:** The above price does include installation, which we will oversee.

**Guarantees:** _____ Gallery warrants that Client will be completely satisfied with the finished painting, and that that same painting will satisfy their expectations artistically and aesthetically. The work will not be deemed complete until Client has expressed that satisfaction.

**Copyright:** Artist owns copyright of the image. The painting can be reproduced on Client brochures, postcards, etc., but only with approval of _____ Gallery and Quacken Donaldbush in writing.

We look forward to executing this work to the satisfaction of all concerned.

In good faith I sign my name to the above.

Paul Dorrell
Director

Quacken Donaldbush
Artist

Hotel Executive
Client

*Figure 4. Sample commission letter*

who operates on the basis of mutual fairness—much as I do.

Regarding the commission for the hotel, we didn't get the price we asked for—which is common—but we did get a price that was acceptable. By the time the installation was complete, the client was ecstatic, the press coverage good, and the success of that work led to other commissions.

Now, let's discuss commissions that might come *your* way.

Let's say you're a painter, and a chic new restaurant wants a mural-size painting. They can only afford to pay $10,000, but you want $19,000. You can turn down the commission, and the chance to have your work in a good venue, or you can accept it and take some of the difference out of their hide in free meals (yes, we've done this). Either way you need the exposure, so I advise you just suck down the low pay and do the job. On your next mural you can charge the $19,000. Of course you should never reveal to anyone what you were paid for executing the first piece, just what you'd be willing to accept for executing a similarly-sized work now.

After that first mural is done, supply the restaurant with biographical cards to hand out, making sure that your name and phone number are on them. If possible, have a framed bio mounted somewhere near the work. Invite the press to cover the installation of the painting, and afterward have an opening.

Just as importantly, once the commission is completed, have the piece professionally photographed and make postcards of it. These, in concert with any press clippings you might pick up, will make a considerable impression on future clients. Be generous with these cards, and make sure they get into the hands of potential collectors.

On the other hand, if you make no effort to promote the work, or to inform the restaurant's clientele of your connection to it, or to show it to prospective clients, you

can be sure that it will have little impact on your career. Every success that you achieve should in some form be promoted; this often leads to other successes. If you fail to promote your achievements, I'm afraid you'll find that all your hard work will not be recognized, indeed *you* will not be recognized, and you'll remain locked within that way of life, and perhaps frame of mind, of the starving artist— a cliché that needs shattering if ever one did.

## Commissioned Paintings Through Galleries

As your career advances, galleries that represent you will hopefully begin securing commissions for site-specific pieces—a task that will be made easier for them if you've already handled a few commissions on your own. Depending on the nature of your work, some of these may be quite large, others relatively small. I've handled scores of commissions, some for as much as $700,000, others for as little as $1,700—all of them worthwhile.

The most common commission I've encountered is where a client falls in love with a painting, but the size is wrong, whether too large or too small. I could let them go away dissatisfied, but nobody gains from that. Instead, I suggest that they commission a similar piece in the size they want. This practice is as old as the art world itself. The only stipulation I toss in is that the two works vary slightly in tone and execution, so that two different clients don't wind up owning the exact same image.

Regarding commissioned paintings of a large size (30" x 40" and up), these will invariably require the execution of a study first. The study will normally be small, say 9" x 12", but whatever the size, it must conform in scale to the dimensions of the larger work. Naturally it must also be a fairly exact reference to how the larger painting will look. The large work will be better defined and probably more inspired, but the study will provide you with a map

of how you're going to execute it. Just as importantly, it will assure your client that you know your business, and will take proper care of their investment.

We always invite our clients to the studio of the artist who is executing the commission, especially as the work is nearing completion. In this way nobody gets any surprises when the work is finished. Normally the client is stunned by the depth of the piece, and offers few, if any, suggestions. If they do offer criticism, which it is my job to interpret, we always listen. While I never allow a work to be dictated by a client, I do pay attention to their wishes. On several occasions I've found their suggestions worth acting on. In the end though, the work remains that of the artist, and all aesthetic decisions must be made by her.

As for my portion of large commissioned paintings, I always take less than 50%—usually between 33% and 40%. Why? Because it's the artist busting her butt on the project, not me; all I did was negotiate the deal. In the case of the previously mentioned hotel project, I took 40%. This was a straightforward landscape, and while not easy to execute, it was far less complicated than an earlier mural I had landed for the same artist, which had involved several figures and a fair bit of research. On that piece I wound up collecting a fee of 33%, since that task was so time-consuming for the artist.

Finally, after the installation is complete, what do you do next? Celebrate. This was a tough job, and you've earned your night of revelry. But after that night is over, do one more thing: get back to work.

## Commissioned Sculpture

Except for a few fundamental differences, these commissions are similar to those for large paintings. Primary among those differences is price. Sculpture will almost always cost more than paintings, and as such you must have a clear

understanding of those costs before you set your price. Go over the costs carefully, check and recheck what your profit is supposed to be, then add twenty percent. The client will likely try to talk you down anyway, so you may as well be prepared for that possibility—and for the fact that you probably underestimated your costs in the first place.

Regardless of your medium, you should execute a maquette, or model, of the large piece in order to flesh out your design, and inform your client of what you intend to do. I know many sculptors who never bother with maquettes when creating a monumental work on speculation. This especially applies to those who work with found objects and raw metals: they simply want to run with the inspiration of the moment, and the materials at hand. But when you're dealing with a client, the rules change. You have to inform them of how the finished work will appear before they'll put down the big money—especially if you're working in bronze.

If you are working in bronze, simply sculpt a clay maquette of the large piece, but don't cast it unless that is in the contract. Whenever I land Jim Brothers a commission to do a monument, we always provide the client with a cast version of the maquette, but only because the casting fee is figured into our overall costs. In other words, our clients pay for the casting of a maquette; we don't, and you shouldn't either.

With most other materials—wood, fiber, steel, ceramic—it is also best to execute a finished maquette. Create it so that it is close to the large piece in terms of scale, design and detail. Of course it will never have the detailing of the large work, which will probably change and evolve as you go up with it. No matter, just explain this simple reality of sculpting to the client. If they're impressed with your other monumental installations, they should trust that you'll handle the finer points of this one just as well.

If creating a maquette just doesn't work for you in your particular medium, then draw the freaking thing. We've done this with large works in glass, where the artist illustrates on paper, in color, how the finished work will appear—more or less. After all it's glass, and changes will therefore occur, which we always explain to the clients beforehand. But because they trust us, and know that the changes will be minimal, they have no problem plunking down the dough after the agreement is signed, and the drawings complete.

My percentage on these larger commissions depends on the medium, and on the nature of the artist's expenses. On big bronze commissions, like the D-Day Memorial, I make 20% of gross. On large projects in stainless steel and other media, I tend to make 33%. Over the years I've found these to be fair and workable amounts. To my knowledge, all my artists agree.

## Copyright

By law, you own copyright on every work of art you produce, regardless of whether you register the copyright or not. Because copyright belongs to you, I advise that you never allow a client, especially a corporate one, to reproduce one of your works without written permission from you. Especially, do not allow a corporation to produce greeting cards, brochures, posters, or any other form of merchandise, without your permission, and without giving you due credit. It doesn't matter if the party in question is giving these items away, or selling them, the image belongs to you. For that reason, only you can give permission to use the image, unless you've signed away the copyright. If you haven't signed it away, and if a client reproduces a work of art without your permission, they are in violation of copyright law.

Adversely, could you ever picture a corporation giving away something they created for nothing? Of course not.

Why then should they expect this of artists? I can't give you an answer, but I can tell you that they often do. Don't let them get away with it. To do so is to perpetuate an already flagrant abuse of our rights, our dignity, and our worth to society. It is the responsibility of each of you, apart from creating your work, to also inspire appropriate respect for it. In some fashion, I do this with my clients every day. I trust that you, and your dealers, will do the same.

### Working with Interior Designers and Architects

I've had scores of interior designers filter through my gallery over the years. Out of all these, there are only a handful that I work with. For the most part, the others are always trying to match paintings with the colors of carpets and fabrics. They don't seem to understand that a painting is a window into another world, and that you don't try to match a window with anything.

I've made dozens of presentations to interior designers, I've addressed them in groups, I've addressed them individually, and still little has come of it. For whatever reason, many of those I've encountered don't seem to speak the language of art so much as the language of decoration. Nor do they seem to understand how difficult the artist's life is. As a reflection of this, I've often had interior designers borrow paintings to show their clients, then fail to return the works when the sale fell through. Worse yet, a decorator once asked one of my sculptors to design a piece for a foyer, then changed his mind about the whole thing without bothering to tell us, resulting in much wasted time on our part. You should have seen the letter I wrote him.

Due to these experiences, I don't bother with interior designers much, except for the handful that I alluded to earlier. As for those golden individuals, do they understand art? Very well. Do I give them a discount? Every time. Do I enjoy working with them? Enormously. These designers

are competent, hardworking people who love what my artists do, and love introducing them to their clients. How could I find fault with that?

Similarly, no matter where you live, there is bound to be a group of designers who do have a passion for art, a firm understanding of it, and great respect for the hardships that artists endure. These designers are very much worth working with. I urge you to find them, get to know them, and, if possible, make fans of them. You'll benefit from the association, and so will they.

My experience with architects has been quite different from that of designers. After all, it was architects who hired me as art consultant for the National D-Day Memorial, as well for a convention center in Kansas City, as well as for a project at the Mayo Clinic. These projects were significant, but when you consider all the hundreds of mailings I've sent to architectural firms, and the hundreds of conversations I've had with architects, the return seems rather small when compared to the effort.

There's a reason for this. Architects, for the most part, *are* artists; their projects are their art. As a consequence, they tend to leave the installation of art up to the client, or the client's interior designer (God help us). Even so, most major architectural firms do have a designer whose job it is to select art for projects where there is a call for it. These people can be very helpful in assisting you with placing your work. As with designers, make sure you get to know them, and that your galleries do the same. One good architectural contact can, over time, bring you more work than you can easily handle—an enviable dilemma by most standards.

## Contractors and Developers

This group is made up, for the most part, of those individuals who are forever expanding our suburban sprawl with massive developments, often made up of massive and

unimaginative houses. By my experience, at some point one of these guys (and they usually are guys) will decide they need a sculpture parked at the entrance to *Foxtrot*, or *Heaven's Gate*, or whatever they call the joint. Once this vision occurs, and if they happen to know of me, they'll call and say, "Son, I hear you're a fine hand at turning out sculptures. I'd like to get us one. Would you mind coming out to the site so's we can discuss it?" Even though it's usually a waste of time, I always ride out to the site so's we can discuss it.

I arrive; the dude escorts me around in his Land Rover or Lexus (If he has two of them, are they then called Lexi?). We look the place over; he asks me for a price on a bronze deer, or two kids romping, or maybe even a contemporary piece. I quote him something in the vicinity of what his car cost, he falls silent, drives me back to my Harley, and says he'll get back to me. Of course I never hear from him again.

A year later I'll drive by the gated entrance, and see a cast concrete Cupid there, or a pair of concrete deer, or just a pile of boulders. Worse yet, he may have found some amateur artist whose talent hasn't flourished yet, paid her a starvation wage to create a piece, and wound up getting exactly what he paid for—without ever knowing, or caring about, the difference.

If you encounter this breed, whatever type of business they're in, I advise you be leery. Some are honest, some are hopeless, but most seem to approach buying art with the same attitude that they use when buying cars, only with less respect. Still, a commission is always worthwhile if the client is reasonable, and the money right.

A clearly worded letter of agreement will handle these people. They must pay one-third of the total price to commence work, the second third when the work is nearing completion, and the balance upon delivery. If at the time of delivery they claim the work isn't what they expected, and

therefore don't want to pay the balance—a scenario that is normally avoided through client consultation—then you retain the piece and refund their money. You can always sell it elsewhere, or your dealer can. It is far better, and more honorable, to do this than be taken advantage of.

In fairness, I must say that I know there are scores of contractors and developers out there who do possess a deep appreciation of art, who show it by treating artists with respect, and also by paying them what they're worth—just as they do their lawyers, doctors and architects. I *know* those guys are out there, it's just that I haven't met any of them yet.

### Websites

I wouldn't have bothered with setting up one of these in, say, 1995, when the Web was less a part of our culture than now. But now I'm obligated to bother with it. *Everybody* has a bloody website, so I have to have a website too.

Actually it's been beneficial, although I've yet to see any great boon develop from it. Art buying, by my experience, is a very firsthand sort of business, where the client normally must see the work before making a decision. This is where the Web is at a disadvantage. But it can serve as a useful tool in introducing prospective clients to a gallery, who can then view more of the artists' works through e-mailed visuals, mailed visuals, or by appointment. The tough part is getting those clients to find you within the informational black hole that the Web has become.

Normally it is easier for a gallery to be found on the Web than individual artists. Why? Because any well-organized gallery will make certain that their web address is listed on all business cards, stationery, postcards and ads. They'll also place their website with a wide variety of search engines. With the amount of marketing that most galleries do, this spreads the information rapidly. Artists, by their very nature,

are less likely to promote their website so extensively.

If you're already with one or more galleries, try to make certain that they include your work on their site. If possible, try to get them to devote an entire page exclusively to your work.

You want to set up your own site? Good idea. Just be aware that setting up a stunning site can be an expensive undertaking, costing several thousand dollars if done through lavish means, or several hundred dollars if done through simpler means (in other words, through a computer-savvy friend). I set up our first site through a freelance designer for a little under a thousand dollars. You can do the same, and probably for much less.

For individual artists, setting up your own site can have obvious advantages. If you're a painter, you can be listed under 'Artists', 'Painters,' 'Muralists,' 'Impassioned Lunatics,' and as many other descriptions as you can come up with. Artists in other disciplines can also be listed under a wide variety of headings. The difficulty lies in making certain that the right prospects are able to find you should they undertake the search.

In all likelihood, few clients will achieve this by tossing an electronic dart into the expanding ether of the Web. As with the galleries, you'll have to file with as many search engines as you're comfortable with. Investigate the ones that would be most relevant to what you do, or simply file with a search engine-registering service that will disperse your site to a variety of other search engines. Also list your website address on all business cards, postcards, etc. Without these steps, your site will just become more and more deeply buried, bringing you little impact beyond the monthly fee you'll pay to maintain it. If it comes to this, you may as well scrap the thing.

Still a refined site can achieve favorable results, especially as you approach new galleries and clients. It will probably

not affect you dramatically, or make you a star overnight, but it will provide one more piece in the myriad puzzle that is your career, and further help in establishing it.

## E-Mailing Images

Of course if you're going to have a website, and if you're going to periodically update it, you will need a digital camera. Yes these can be expensive, but in the long run they will save you money in developing costs, will save paper, and time. Utilizing a digital camera is, currently, the easiest way to update your site. It is also a simple way to inform your galleries and clients about new work, since all you have to do is e-mail them an image. This is far simpler, of course, than photographing work the traditional way, and then mailing the photos.

Once you have a digital camera, does this mean that you can automatically begin e-mailing every gallery in the country, encouraging them to visit your site? Not by my recommendation. When I come into the gallery in the morning, get my coffee, read a passage of Shaw, and finally get around to checking my e-mail, I always groan when I see one of those multiple submissions, opening with a form letter.

In all likelihood the artist knows nothing about our gallery, and performed no research to see if we're even suited to carrying her work. Worse, she hasn't even bothered to write me a personalized note. Frankly, if she doesn't care enough to carry out these basic steps, why should I open her e-mail? I don't, and won't. It simply goes in the trash.

However if the cover letter is personalized, if the artist has obviously taken the time to learn about the gallery, and if the submission is concise and well-organized, I will look at it—or one of my assistants will. *That* is how I discover new talent, or, just as importantly, encourage developing talent to continue developing. After all, that too is a part of

my job. I'm not just here to sell work by established artists, I'm here to help perpetuate the development of the arts, on both the side of the collector and the side of the creator. It's more fun that way, and certainly more rewarding.

In the end, though, the only thing that will really catch a gallery's attention is mailed visuals—slides, photographs, postcards. But starting with e-mailed images can be a very good introduction, especially if it's done with forethought, consideration and flair. So yes, utilize the internet in this respect if you're so inclined. Once you learn the proper techniques, I think you'll find it a highly effective medium.

### Utilizing Reproductions—Both in Magazines and as Prints

This subject applies primarily to painters, but it can apply to other artists as well. The most basic overall application relates to magazine covers: interior design magazines, lawn and garden magazines, magazines for medical societies, architectural associations, and so on. Many of these publications welcome the opportunity to reproduce an image of a work of art, be it painting or sculpture, on their covers. Many others may have never done it before, but might be open to suggestion. Have your dealers suggest it to them, or suggest it yourself.

The Kansas Medical Society has made a practice of this, as has the Missouri Medical Society, and both have reproduced images for my artists. I've arranged the same with scores of other publications, both major and minor. I rarely charge a copyright fee though, since I feel that the exposure is what's most important, and I don't care to complicate the deal with a demand for what is usually just a small amount of change.

Reproductions can also be used for certain types of corporate brochures, hotel brochures, restaurant menus, etc.

Example: It was just this sort of reproduction that launched Maxfield Parrish's career. In his case, a candy manufacturer

out of Cleveland asked permission to reproduce one of his paintings on their boxes. Parrish agreed to do this for a modest fee, the boxes were printed and distributed by the thousands, and within a year, he was signing a contract to distribute reproductions of his best originals. This in turn led to an increased demand for his originals, also increasing the prices he could get for them, and in the end gave him the leisure to finish his paintings in just the way he wanted. Since he tended to spend as much as a year on some of his more complex works, that leisure was critical.

Similarly for you, if you're a painter, reproductions of originals can be a very lucrative, career-enhancing move. It can also be a flop, depending on how it's managed, and who manages it. Normally it's best if a gallery handles this, although the painter should be involved in every step of the reproduction process, especially the proofing.

How do you go about it?

First, you want to start with the strongest possible painting. After choosing an image that you and your dealer feel will sell well, you then have to choose the best reproduction process for your purposes. These choices generally are: offset color prints on archival paper (glorified posters), giclee prints on archival paper (extremely glorified posters), or just posters. I've dealt in the first two options for certain artists, and have overseen the production and distribution of these prints to various frame shops. Over time, the wholesaling of these works can pay quite well, but the main reason I do all this is to make my painters better known, and to sell more of their originals. This invariably occurs if the marketing of the prints is done competently.

If I cover the cost of production, then I pay the artist 20% of gross sales. If the artist covers the cost of production, then I keep 20% of each framed piece I sell—assuming the artist or some frame shop did the framing, and

they normally do since I can't stand framing, and refuse to do it (don't ask why, that's just one of my quirks).

Apart from the types of prints listed above, there are also fine art prints: etchings, lithographs, mezzotints, aquatints, etc. For the artist skilled in any of these processes, these are a wonderful way to showcase your talents without charging the higher fees that originals necessarily command. It's more difficult to mass-market these, since they tend to be more expensive, and since they usually don't utilize much, if any, color. But then they're not made for the mass market, and shouldn't be viewed in that light. These types of prints are works of art unto themselves, and that is the only light in which they should be viewed.

Reproductions aren't for everyone, but if you and your dealer feel you might carve a niche in that market, go ahead and pursue it. I advise you to start gradually though, working in small editions (100 to 300), and investing as little as possible. It's better to test the market this way, than it is to invest heavily in prints, and find out, perhaps too late, that no matter how stunning they might be, you can't even give them away. This happens more often than not; you don't want to be one of the people it happens to.

### Grants

This is strange, tricky ground for me to cover, but I wouldn't consider the book complete without addressing the subject.

The mystery of grants and who is awarded them, and why, is something most artists can't explain, don't comprehend, and have given up trying to. Many artists have also given up on applying. In fact I scarcely know of a single successful artist who even bothers applying for grants anymore, although most of them did when they were younger—and a handful were even awarded one.

The majority of artists don't qualify for the major grants until they've established themselves as proven, exhibiting artists. The sad thing is, the ones who really need the help are those on the way up, not those already established. Mapplethorpe didn't necessarily need a project grant when he was awarded the National Endowment for the Arts gig that aroused so much outrage. Several established artists don't need project grants either, but are awarded them anyway. Why? For recognition, I suppose, although it would perhaps be wiser to bestow the recognition in the form of a medal and a shindig, and save the grants for the struggling, but as yet unrecognized, artists of comparable talent. Sometimes those artists are assisted, but I find that all too often they are not.

Anyway, NEA grants have changed considerably since the Mapplethorpe blowup of the nineties. For instance, they no longer award grants to individual artists. The NEA's Visual Artist Fellowship Program ended in 1996, when Congress altered their legislation. At this time, NEA grants in the visual arts only go to nonprofit organizations that present exhibitions, commission work, host residencies, and provide studio space for artists.

The Mapplethorpe exhibit received this kind of grant; it did not go directly to him, although an earlier grant did. But even though the grant in question did not finance Mapplethorpe's photography, his work did benefit from the exhibit (as well as from the resulting firestorm), which was the purpose of the grant in the first place, so it did achieve its end. Of course that particular controversy was very hard on the NEA, which is unfortunate, considering how small the grant was in comparison to the scope of what is often a very worthwhile program. But such are the risks in mixing government monies, and therefore politicians, with art.

As for the entire fellowship system itself, it seems to me that many grant organizations are primarily interested

in assisting artists whose work has a certain shock value. Artists who are more tradition-based are typically ignored. That's bold, I suppose, perhaps even courageous, but after awhile it becomes tedious. Whatever became of grants based on discipline, talent, vision and craft? Or is this just too old-fashioned a concept for certain endowment organizations to consider? And don't hand me that nonsense about how if you don't understand shock art, you're intellectually lacking. Our society, our *whole world*, is daily exposed to shocks that are far more disturbing than anything any artist can conceptualize, or create, in attempting to awaken the indifferent and dozing portion of our populace.

The Dadaists did all that nearly a century ago anyway, shocking anyone who they felt needed to be shocked—and many people did. There has long been a need for shock art; there probably always will be. How else can new movements, and explorations, be born? Still I feel we've gone to many of those extremes already, in fact had to go there in response to the hypocrisies of the World War I era, as well as several eras since. Perhaps now, though, it's time we moved back a tad in the other direction. Perhaps we could use *that* kind of shock now.

State-sponsored grants are just as tough to get as the federal variety, and just as hard to figure as to why certain artists receive them, and why others are passed over. I've been told by artists who have received both federal and state grants that it's a terribly political process, where inside connections and acquaintances will take you farther than the substance of your work. I'm sure there are many instances where this is true; I'm sure there are just as many where this is false. But that's life in this world: it's been political since the first society was established, it will remain political as long as any organized society exists.

Despite all the gripes I've listed above, I consider it good organizational practice to submit for grants. It will teach

you the importance of quality photography, resume layout, and overall presentation. Be warned though, the competition for most grants is so immense that the chances of being awarded one are next to nil. This doesn't mean that you shouldn't apply; I'm only trying to make you aware of the odds—rather like those of trying to get a literary novel published.

Applications for most types of grants can be obtained through civic and state art commissions, as well as the NEA. A simple call to your local art commission will set you on the trail of where to get the paperwork, and how to go about applying.

My personal take on all this? Individual grants disturb me somehow. I fear that if I were awarded one, or more than one, I might become dependent upon the grant instead of upon my discipline, which to me is frightening. Of course I know that grants are meant to help buy the artist time in exploring, and developing, her work, which is a wonderful thing in those instances where the talent is worthy, and the grant warranted. Gauguin could have only dreamt of such a windfall, and in a sense gained one, when he convinced the French government to pay passage for his first trip to Tahiti, as well as the return trip two years later; but they paid for nothing else.

Still in some ways I view grants for the individual artist as a well-intended but sometimes misguided attempt to soften the harshness of the artist's life. The intent is noble, but it's somewhat akin to interfering with someone else's fate, when that fate is something they need to go through.

The artist's life is *supposed* to be harsh to a certain degree. If it isn't, what will inspire you to reach higher than your immediate grasp? If conditions are made too easy for you, isn't it possible that you'll shortchange yourself, as well as society, with whatever you wind up producing? In the cases where the grant system has been abused—when the money

subsidized a drug habit, a drinking habit, or just the perpetuation of mediocrity—I find this has sadly been the case.

Still if I were awarded a grant tomorrow, would I turn the money down? Better yet, would I have the guts to hand it over to some struggling, but dedicated artist who needed it more badly than I? If I were flush, yes. If I were broke, no. I'm as human as the rest of you, but you know that by now.

### Compromise, and One Example of It

To me, one the best examples of compromise is cradled in the story of the Vietnam War Memorial. As most everyone knows, the design of the memorial—with its angled granite walls, the seemingly endless list of names, and the installation itself like a wound in the earth—is simplicity in one of its most powerful forms. The fact that such a young student, Maya Lin, (twenty-one at the time) designed something of such visual impact and grace is a tribute to her intelligence, as well as to her sensitivity to the issue. I've been several times to the wall, have watched the veterans and their families weep, have wept myself.

One of my brothers served in Vietnam, was wounded there, then shipped back to the states half-insane, dying twenty years later as one more casualty of that awful war— as all wars are awful. In a sense his name belongs on that wall too. Maybe that's one reason why I like visiting it.

When the wall was dedicated in 1982, it inspired a level of emotion and healing that most war memorials don't, and it did so with a minimum of sentimentality. It is still doing this. As long as Vietnam veterans are with us, it probably always will. But at the time of its dedication, many of those vets were not fully satisfied. Because there was no figurative representation of them, a large number felt that the installation was incomplete. As with the Iwo Jima Memorial, Grant's memorial, and other war memorials across the country, these guys wanted bronze figures, and

they wanted them at the site. They made this known, and then there started a bitter debate.

Some critics argued that the placement of such figures would disturb the integrity of the memorial, and amount to stooping to sentimentality. I understand the argument, but I found it then, and find it still, the height of arrogance. Did any of those critics fight in the war? Did any of them lose an arm or a leg or the outright ability to walk? Did any of them soil their pants under fire, or scream for their mothers when wounded, or watch others scream for the same as they died? I suspect that few, if any, did. On that basis alone they had no business making such arguments, let alone telling the veterans what was best for them.

The men who fight our wars usually are not highly educated, often have no choice but to serve, and almost never have any use for contemporary art. Usually it just doesn't relate to their world, or to how they perceive the rest of the world. The vets wanted figures in bronze, and finally when Frederic Hart was commissioned to execute them, that was what they got.

The solution was to situate the sculpture some hundred yards from the memorial but facing it, with the three grunts having just finished a patrol, likely to soon go out on another, and from that one perhaps not return. A black man, a white man, and one who could possibly be interpreted as Hispanic. The placement of this monument was a brilliant compromise. It didn't interfere with the design of the memorial, and satisfied the visual needs of the men who did the actual fighting.

For my part, I've always felt that these figures were a little too idealized, that they don't look shaken or drained enough, and that the emotional price they were paying doesn't show plainly enough on their faces. This doesn't detract though from the symbolism of the grouping, or from its appeal, or from the effect the piece has on viewers to the site.

There *can* be compromise between the traditional world and the contemporary. The two don't have to exist separately, and nobody really needs to feud over which is legitimate, and which is not. History, with the benefit of hindsight, makes those assessments for us, and all of our squabbling will have little effect on the outcome. Many of these arguments might be worth pursuing, but never as an affront to sacrifice, dignity, or loss.

You will have to learn compromise too. A stonewalled failure to do this will only bring you more grief than accomplishment, and more frustration than achievement. But it doesn't hurt to try living without compromise for awhile. Doing so teaches valuable lessons, normally of the sort that, once learned, we tend to never forget.

Then there are people like Frank Lloyd Wright, a man who almost never compromised about anything and never felt the need to. To a degree this worked for Wright, being a genius, but whether it was worth the trouble it caused him is something I don't know. I know it wouldn't be worth it to me, but then I'm not a genius.

### Self-Doubt

Every living artist I've ever worked with, and every deceased artist I've ever studied, have all shared one simple trait: each of them has gone through varying levels of self-doubt; each of them, at different times in their lives, has questioned the worth of their talent. No one that I know of has ever been exempt from this. For some, like the poet Sylvia Plath (who was also a talented illustrator), their spells of doubt and depression were mind-numbing, paralyzing, and, in the end, beyond their control. For others, like Picasso, those spells were nothing more than a minor dip on their emotional graph.

However severe or mild your spells might be, I bring this up to assure you that they are common, and that, after you

weather each one, your confidence and perceptions will likely grow—provided that inner growth is a process you embrace.

I feel that spells of self-doubt occur so that we will reassess our lives, and work. For some, these periods can virtually destroy them if they don't keep their emotions in check. But for most artists, the spells serve as a tool for reevaluating their work, and deciding whether they want to continue in the same vein or not. In other words, this entire process is a necessary thing and, like most occurrences in life, can have a positive outcome—but only if you decide that it can.

Yes, you're supposed to enjoy the gift of creation, and create with it what you can. But if that gift doesn't on occasion hurt, if it doesn't make you howl with self-deprecation and questions of self-worth, if you don't sometimes wonder whether everything you've done up till now is crap, then something's wrong. You're *supposed* to feel these things. They help keep you on the edge of your passions, your inspiration, and your drive.

However it strikes you, please don't believe that self-doubt is limited to you. We all share it, we all struggle with it, we all struggle to overcome it. Let it serve you in the way that it's meant to, but always try to stay in control of it. Like so many powerful emotions, this one too contributes to the energies of creation.

How do you break free of it? You can discuss it with friends, you can whisper about it at night with your lover, you can reread this passage, but really there's only one way that I know of to break out, and that is through work. Work, and then more work, and yet more work after that. That is what you're here to execute, that is what you must continue doing, no matter what it takes, or what it takes out of you. Besides, the thing it gives back is always far richer than the thing it takes away.

## Expanding Career

As you evolve, and as your work evolves, always be willing to follow any path that excites you, that demands a higher level of discipline, or maybe just a higher level of being. Try to avoid falling into ruts of complacency or habit.

At the same time, if you eventually discover a style that works well for your sensibilities, and your market, there's nothing wrong in staying with it. You don't have to reinvent the wheel every five years, or every ten, to maintain your sense of artistic integrity. You paid a heavy price in establishing your style, and have earned the right to reap from it all you can.

How many haystacks did Monet paint, and how many paintings of the same stack did he do? Dozens. Did this harm his career in any way? To the contrary, it advanced it. Sure, some pseudo-intellectuals of the time derided him for this practice, and others may also deride you. They may say you've betrayed your talent, or some artistic truth, or whatever. Let them. They're not the ones doing the work, they're only doing the talking. Which act, I ask you, is of greater worth?

There does come a time though in most artists' careers when they must reassess where they've been and where they're going. A change normally follows. If your intuition is on target, your talent psyched, and your passions aroused, this change will in all likelihood be a good one. But even if none of these elements are in alignment, you'll still have to attempt a change now and then. Doing so will help keep your work fresh, and keep you from getting bored, since if you grow bored with your work, it will inevitably begin to bore others.

Example: Arlie Regier, one of my contemporary sculptors, had been successfully sculpting in painted steel for twenty years when I first met him. He'd created hundreds of pieces, and had placed every one. Then he grew bored

and began experimenting with stainless steel: found objects, fabricated objects, polished surfaces, intricate designs. When he was ready, he showed me the new work. I took one look at it, told him to forget painted steel, and to concentrate solely on stainless. His intuition proved correct, and to this day the various galleries that carry his work can never stock enough of it. Even now the stainless pieces continue to evolve, as he and his son Dave devise new concepts. This keeps them challenged, and keeps up my clients' interest.

Not every change can be met with such success, but you won't know if you don't try. When the time is right, you *must* try this; if it fails, you can always go back to what you were doing before. But if you don't make the attempt, you'll be denying yourself the chance for growth. And growth, regardless of whether or not you're an artist, is one of the primary themes of life.

## Museums: Gaining Their Acceptance

Eventually, if your work has received sufficient notice, you and your dealers should consider placing it in museums. There's no point starting with the larger museums, since they likely won't give you the time of day, or night, but it does make sense to start with some of the smaller ones in your region. It doesn't really matter if it's a museum of fine art, a historical museum, or a combination of the two, so long as your work is placed and the setting is appropriate.

As far as knowing when to approach a museum, I can tell you that you'll have to have achieved a great many successes before you even consider it—unless you have a rich uncle on the board. But with or without the uncle, you will have to be reasonably established, successful, and mature in your career before even the smaller museums will consider your work. Once you, and your dealers, feel you are

at this point, then pursue the museums as ardently as I pursued gaining an agent, only don't do it yourself. Have one of your dealers do it for you. There's nothing wrong with having a representative brag about your work, but of course it's considered bad form for you to do it.

If, after many false starts and rejections, you do gain a museum's interest, try to avoid donating the work. If the museum values what you create, they'll either raise the money for the acquisition, or ask a patron to step forward. You *can* let them have the piece at a wholesale price however, since it is better to place the work and make minimal profit, than to not place it at all.

As always, if you achieve this, announce it in any papers that are willing to carry the story, add the line to your resume, and have your dealers make note of the same. If the acquisition is significant enough, have your dealers mail out an announcement to their clients. Finally, if you get enough of the smaller museums to carry your work, it will then be time for the larger ones to be approached—probably after *you're* dead. That's usually when they show the most interest. But that's life in the arts.

When the time is right, go after the museums, no matter how unlikely it may seem that you'll achieve your goal. It's doubtful that many of you will place work in the larger ones—I haven't for any of my artists yet—but for those of you who do, it obviously will be a step of considerable magnitude. It will also be reason for another celebration. Yeah, as you may have guessed by now, I'm pretty big on celebrations.

### Snobbery: Another Word for "Wasted Intelligence"

I suppose I could be a snob in writing about snobs, and thus out-snob them, but there's no winning that game, and anyway it's undignified. Compassion is the best way to treat snobs, even if they don't seem to deserve it. Just

remember, they too are only trying to fit in, like the rest of us. Perhaps snobbery is the only thing they've found that works. Except it doesn't work; it only leads to misery and emotional isolation and, I don't doubt, a great deal of depression.

Each time you encounter a snob, try to bear this in mind: inside virtually every one of them is a child who was scorned on the playground, or in the classroom, or perhaps at home. Inside every snob is a frightened person who is still trying to learn the song of life, except all they have is the words, not yet the music. That said, I'd like to ask you, which do you think snobbery is primarily rooted in: insecurity or confidence? Notice how the question answers itself.

I don't care how well-educated, or from what social strata, anyone who behaves snobbishly about the arts is doing artists a disservice, potential patrons a disservice, and themselves a disservice. To scorn people who are not well versed in the arts, or well-educated, is an antiquated way of viewing life, and a poor use of intelligence. What it really amounts to is bullying.

Example: If a working-class woman is a single mother who missed college, whose every day is filled with adversity, yet who is aware of her ignorance and wants to alter it, does that make her inferior to the upper-class esthete? If she comes to a gallery for escape, should she be treated with disdain if she asks a naive question? Or should she be treated with interest? Ditto the manual laborer, the hairdresser, and even the uninformed businessman. Yes, all these people should be treated with respect, but often a snob doesn't understand this basic truth of life.

The snob will talk down to them, laugh at them after they've left, and go home thinking that a minor victory has been scored, when all they really did was deepen their misery, and discourage their victim from branching out. But

the snob doesn't stop there: they will laugh at you, they will most certainly laugh at me, and inevitably they laugh at each other.

Who do they help with this attitude? No one. Who do they hurt? Primarily themselves, only they often don't realize it until late in life. What good do they do? Very little, except in the sense that if you respect their opinion, they may cause you to strive harder than you would otherwise; they may inadvertently help us to keep our standards high. That isn't all bad, but it doesn't outweigh the boatload of negativity they bring to the table.

Whatever you do, wherever you meet them, don't let the snobs discourage you. They have always been a part of the arts, and always will be. They have their place, and I suppose must occupy it. That isn't my concern: *you* are my concern. Don't let them ruin the thing you're developing a passion for. Remember, the only reason they behave as they do is because they are intimidated by life; they just chose an unfortunate manner of coping. Any educated person can be a snob, but it takes strength to live with understanding and compassion.

If snobbery isn't one of your problems, be grateful. If the art world is primarily one of play for you, then just keep on playing. The best work comes from that sort of inner freedom. Good work can also come from attitudes of disdain and elitism, but what a way to live. I certainly wouldn't choose it, and tend to feel badly for those who have. Life's tough enough without making enemies at every turn, but some people just seem to have a need for that.

### Expanding Life

As your work goes, so will your life. One will be a reflection of the other, although not necessarily in any particular sense or order. The better your work gets, the more fulfilled you'll likely be. That notwithstanding, I've known plenty

of artists whose work was brilliant, but who remained depressed and semi-neurotic just the same. I've also known many whose work was just average, but who were among the most contented people I've ever met. Why? I have no simple answer really, just observations.

If I observe any consistency in contentment among artists, and people in general, it's that those who take themselves the least seriously, enjoy themselves the most. They might take their work dead seriously, but somehow they keep from entertaining too lofty a view of the person creating it. This allows them to have fun, and having fun is essential to the enjoyment of life. It's a childlike quality, sure, but certain childlike qualities are good to hang onto. This, to me, is one of them. But don't take my word for it, take old Bertrand Russell's (twentieth century English philosopher, for those of you who skipped your Western Civilization courses):

"The decay of art in our time is not only due to the fact that the social function of the artist is not as important as in former days, it is due to the fact that spontaneous delight is no longer felt as something which it is important to be able to enjoy . . . As men grew more industrialized and regimented the kind of delight that is common in children becomes impossible to adults, because they are always thinking of the next thing, and cannot let themselves be absorbed in the moment. This habit of thinking of the 'next thing' is more fatal to any kind of aesthetic excellence than any other habit of mind . . ."

But Frank Lloyd Wright said it more directly, and more succinctly, on the occasion of his eightieth birthday:

". . . a creative life is a young one. . . .What makes you think that eighty is old? The purpose of the universe is play. The artists know that, and they know that play and art creation are different names for the same thing."

Another thing I've noticed is that the most contented artists tend to be among the least selfish. They went through all the selfish stuff years ago, wearied of its emotional weight and lack of grace, and discovered that giving to others always brings a greater bounty than it costs, whether giving emotionally, materially or spiritually. In this way they don't become too self-absorbed, they remain grateful for what they have, and for what they've achieved—not a bad approach to both your work and life.

Whatever difficult things you experience, whatever the tragedy or sense of inadequacy or depression, try to remember that you are not alone. Most of us have been there, most of us will be there again. Harsh experiences on the road to self-awareness are common—far more than we usually care to admit—and in many instances necessary. Without them you'll never adequately shape your character, or your art.

If you can take solace in nothing else, take solace in that. Then get up, dust yourself off, and move on. You have to.

# CONCLUSION

## *Success*

Success, as you likely know, can really only be defined by the person achieving it. In my opinion, it has less to do with material wealth than it has with achievement, inner fulfillment, and artistic mastery.

I've known some artists whose work was, to me, nothing short of spectacular, who had achieved astounding wealth, enormous critical acclaim, and yet whose inner life, family life and emotional life were unspeakable wrecks. This to me was hardly a measure of success, and yet nearly all of these artists considered themselves successful, as did the public.

I've also known many other artists whose work was spectacular, who had achieved only moderate prosperity, almost no critical acclaim, and yet who seemed incredibly fulfilled in all areas of their life. These people too considered themselves successful. So did their collectors. So did I.

Myself? I tend to break success up into different categories. I've always felt successful as a father, normally felt it as a husband, and for years now I've felt it as a man, despite some of my deeper and more enduring depressions. As a writer, I never considered myself successful until I got a book published, and until that book had begun to sell—regardless of how well-written I was told that the unpublished ones were. Equally, as an art dealer I never

felt successful until we were solidly in the black, despite the fact that during the early years, nearly everyone who knew of my gallery considered it a great success.

As for you, you'll know your own measure of success when you achieve it, with it likely being defined by how you view the same. Over the years that definition may change, depending on the nature of your experiences, disasters, and victories. Whatever happens, just try to make sure that you learn from each disaster and are grateful for each victory. Try to make the end-result of each change positive, rooting it in your artistic and moral integrity, balancing it with common sense. You don't possess that last trait? Then try to spend time with people who do, and who care enough to extend it to you. But of course in order for that process to work, you will have to be willing to do one simple thing: listen.

### Failure

What happens if you "fail" and have to join the business world, or some world similar to it? The truth is, you haven't failed. All those years of struggle, adversity and wrestling with the muse have brought, in return, these years of growth and a hopefully mature outlook. Without the struggle you wouldn't have the growth. Besides, the working world isn't all that bad. You could do worse. You could be living in Somalia or Bosnia and have no prosperous world to join at all, only deprivation and hardship.

If you're compelled to join, or rejoin, the working world, just pick a company that is sane, and that treats its employees sanely. You'll still have your work and, if you're like most artists, nothing will keep you from it. You may have to burn more midnight oil to stay with it, you may lose weight, you may lose sleep, you may lose a bit of your inner balance, but the struggle will bring out even more insight and, if things go well, better work. Follow your inner voice.

It will take you where you need to go. That may not necessarily be where you want to go, but usually where we need to go is the more important of the two destinations.

Joining the world of the full-time employed is not necessarily a surrender; it is taking time out to face what you need to face—in your work, yourself, and your life. If you have it in you, you'll bring out your best work no matter what you have to suffer, overcome, or go through.

Take yourself a little bit seriously (no one else will), but not too seriously. Learn to laugh at your mistakes and to admit your weaknesses. There is strength in the one and humility in the other, and both, in doses, are a necessary part of the process.

Oh, and one other thing. Never give up, never give up, never give up. Don't betray your talents by destroying them, or turning on them, or walking away and saying it can't be done. You don't have that privilege, nor usually even that choice. I know, I tried it once and madness was nearly the result. I won't try it again.

Now put this freaking book down and get back to work. And whatever you do, don't tell me how hard it is. Don't even tell yourself. It's supposed to be hard. Only mediocrity is easy, and you're too good for that.

## *The End*

*"My dear brother, if I were not broke and crazy with this blasted painting, what a dealer I'd make."*

Vincent van Gogh, in a letter to Theo.

# Selected Bibliography

Philip Callow, *Vincent van Gogh, A Life*, Ivan R. Dee, Inc., Chicago, 1990

F. Scott Fitzgerald, *Tender is the Night*, Charles Scribner's Sons, 1933

Sue Davidson Lowe, *Alfred Stieglitz, A Memoir/Biography*, Farrar Straus Giroux, New York, 1983

Friedrich Nietzsche, *Beyond Good and Evil*, Oxford University Press, Oxford, England, 1998 (translation by Marion Faber, 1998)

Meryle Secrest, *Frank Lloyd Wright,* Alfred A. Knopf, New York, 1992

Anne Stevenson, *Bitter Fame, A Life of Sylvia Plath*, Houghton Mifflin, Boston, 1989

David Sweetman, *Paul Gauguin, A Life*, Simon and Schuster, New York, 1995

*Complete Letters of Vincent van Gogh*, Little Brown, New York, 1958

Jacqueline Bograd Weld, *Peggy, The Wayward Guggenheim*, E. P. Dutton, New York, 1986

# Illustration in the Text

Randolph Caldecott: Illustration for *Breton Folk* by Henry Blackburn, James R. Osgood and Co., Boston, 1881

# LIVING the ARTIST'S LIFE

Would you like to order this book for a class?
Would you like to send it to a friend?
Either way, it's simple.

Just log onto our website: **www.hillsteadpublishing.com**

Or e-mail us: **email@hillsteadpublishing.com**

Or call our toll free number: **1-866-816-8022**

ISBN 0-9749552-0-5   $16.95, plus $6.00 for Priority Shipping

Please allow ten business days for delivery. For information on quantity discounts, please call us or refer to our website.

## Hillstead Publishing
4741 Central, #213
Kansas City, MO 64112

Paul Dorrell is the founder of Leopold Gallery. He has worked as art consultant for the National D-Day Memorial, the Mayo Clinic, DLR Group architecture, and a host of private collectors. His monumental projects have included a presidential dedication, and an installation in the Capitol Building, Washington, DC. He has lived in New York, Italy, Spain and England. Currently he lives in Kansas City with his wife and two sons.